Our Land/Ourselves

AMERICAN INDIAN CONTEMPORARY ARTISTS

An exhibition
organized by the
University Art Gallery,
University at Albany
State University
of New York
Nancy H. Liddle, Director

Jaune Quick-to-See Smith,
Guest Curator

Essays by
Paul Brach
Rick Hill
Lucy R. Lippard

Circulated by the
Gallery Association of
New York State, Inc.

This publication is made
possible by a grant from
NORTHERN TELECOM, INC.

Our Land/Ourselves

AMERICAN INDIAN CONTEMPORARY ARTISTS

Published by the University Art Gallery
University at Albany, State University of New York
H. Patrick Swygert, President

Catalogue Design by WilliamPadgettDesign, Erieville, NY
Edited by Deborah Ward
Editorial Assistants
Jeanne Laiacona
Joanne Lue

Photography by Courtney Frisse, Syracuse, NY
Additional photographs by David Broda, Syracuse, NY

Text was set in Adobe® Garamond and page
layout performed on QuarkXPRESS® with a
Macintosh computer. Film output on a Linotronic 300
imagesetter at Canfield & Son, Utica, NY.
Three-thousand copies of this catalogue were
printed and bound by Thorner-Sidney Press, Inc.,
Buffalo, NY on Potlatch Vintage Velvet #100
text and cover.

ISBN #0-910763-05-4
Library of Congress Catalogue Card No. 90-07-1736

Cover: George Morrison, *Spirit Path. New Day. Red Rock
Variation: Lake Superior Landscape,* 1990 (detail)

EXHIBITION ITINERARY

University Art Gallery, University at Albany
State University of New York
February 1 – March 17, 1991

Robert Hull Fleming Museum, University of Vermont
Burlington, Vermont
April 12 – May 24, 1991

The Art Museum, The Museums at Stony Brook
Stony Brook, New York
July 7 – August 11, 1991

College Art Gallery, The College at New Paltz
State University of New York
September 10 – October 10, 1991

Joe and Emily Lowe Art Gallery, Syracuse University
Syracuse, New York
October 25 – December 1, 1991
Made possible by the Maurice and Sheldon Horowitch
Foundation

University Art Museum, State University of New York
at Binghamton, New York
January 17 – February 17, 1992

Myers Gallery, SUNY Plattsburgh Art Museum
Plattsburgh, New York
March 7 – April 18, 1992

Tyler Art Gallery, State University of New York
at Oswego, New York
September 3 – October 20, 1992

Herbert F. Johnson Museum of Art, Cornell University
Ithaca, New York
November 3 – December 17, 1992

Thomas J. Walsh Art Gallery, Fairfield University
Fairfield, Connecticut
January 10 – February 13, 1993

Rochester Museum and Science Center
Rochester, New York
April 7 – May 16, 1993

TABLE OF CONTENTS

CORPORATE AND FOUNDATION SPONSORS

The University Art Gallery is deeply grateful to the following corporate and foundation sponsors. Their commitment to the arts as viable paths toward multicultural understanding has made this project possible.

THE FORD FOUNDATION
NORTHERN TELECOM, INC.

Bullard and McLeod
Desmond Americana
Hudson Valley Paper Company
Key Bank of Central New York N.A.
Key Bank of Eastern New York N.A.
New York Council for the Humanities
New York Power Authority
Omni Development Company, Inc.
The John Ben Snow Trust
University Auxiliary Services at Albany, Inc.

CURATOR'S STATEMENT

In 1854, Chief Seattle said: "Every part of this earth is sacred to my people. Every shining pine needle, every mist in the dark woods, every clearing and humming insect is holy in the memory and experience of my people. The sap which courses through the trees carries the memories of the Indian. We are part of the earth and it is part of us.

"The perfumed flowers are our sisters; the deer, the horse, the great eagle, these are our brothers. The rocky crest, the juices in the meadows, the body heat of the pony and humans—all belong to the same family…"

Chief Seattle's eloquent words have been repeated by the Greens in Germany, environmentalists around the world, and myriad others, including corporations.

In the same speech over 100 years ago, Chief Seattle also predicted today's environmental problems in his visionary declaration:

> We know that the white man does not understand our ways. One portion of land is the same to him as the next, for he is a stranger who comes in and takes from the land whatever he needs. The earth is not his brother, but his enemy, and when he has conquered it, he moves on. He leaves his fathers' graves behind and he does not care. He kidnaps the earth from his children and he does not care. His father's grave and his children's birthright are forgotten. He treats his mother, the earth and his brother the sky, as things to be bought, plundered, sold like sheep or bright beads. His appetite will devour the earth and leave behind only a desert.

Truer predictions have never been made.

When Nancy Liddle, director of the University Art Gallery, first approached me about curating an American Indian exhibit, I suggested an exhibit which dealt with the land.

I feel this is particularly timely with the upcoming 1992 Quincentennial and with the current environmental problems we are facing. Scientists and environmentalists worldwide are now turning for answers to the deep and abiding ecological science of the Indian peoples.

Euro-Americans often wonder why the American Indian is so attached to the land. Even after Indians have lived in an urban environment for two generations, they still refer to tribal land as home. This continuum is made tenable by several factors.

Each tribe's total culture is immersed in its specific area. Traditional foods, ceremonies and art come from the indigenous plants and animals as well as the land itself. The anthropomorphism of the land spawns the stories and myths.

These things are the stuff of culture which keep identity intact.

The artists in this exhibit take multiple approaches to describing land/landscape. It is more rare to find a horizon line than not. It is more rare to find political content than not. It is more rare to find realism than not. But however the artists execute their work, whether celebrating human interaction with the land or cautioning the destruction of the land, they weave their distinct conceptions in and through an interior view.

I am proud to be associated with this exhibit and thank Nancy Liddle for the curatorial opportunity. I also owe a debt of gratitude to my brothers and sisters who continue to enthrall and enlighten me. And finally, I want to thank my friends Paul Brach, Rick Hill and Lucy Lippard for their sensitive and insightful writing.

JAUNE QUICK-TO-SEE SMITH
Curator

INTRODUCTION AND ACKNOWLEDGMENTS

The initial impetus for organizing this exhibition came from a series of trips to various parts of the U.S. to increase my knowledge of contemporary art activity outside the major art centers. A longstanding interest in historical American Indian art led me to search particularly for contemporary activity in the Native American art world in the Northeast, the West Coast and the Southwest. Although I was aware of artists who had "made it" in the mainstream; i.e., T.C. Cannon, James Havard, Jeffe Kimball, George Morrison, Fritz Scholder and others, I mainly searched for less-known artists who were being educated in and teaching in colleges and universities and whose lives were influenced by both their tribal backgrounds and their awareness of 20th-century American and European art.

A study leave and two travel awards—one from New York State United University Professions and one from the University Commission on Affirmative Action—made it possible for me to consult with artists and curators across the country who knew artists who were working in contemporary ways. In the Eastern United States my consultancies with Lee Callander, the head registrar at the Heye Foundation in New York; Lloyd Oxendine, the museum director at the American Indian Community House Museum in New York; the Iroquois artists Peter Jemison and Jolene Rickard; and the artist/curator Rick Hill helped me get underway and made me aware of the political realities and the diversity of opinions surrounding contemporary Indian artists and exhibitions. Kay WalkingStick, who was at that time on the art faculty at Cornell University, expressed unbounded enthusiasm for the idea of an exhibition which focused thematically rather than ethnically.

In San Francisco I became acquainted with the strong programs of the American Indian Contemporary Arts gallery in San Francisco and the West coast artists Harry Fonseca, Frank LaPena, George Longfish and Mario Martinez.

Like everyone else who is interested in the subject, I made the required pilgrimages to Santa Fe and Albuquerque because it is in those places that Indian artists have always received the most consistent attention. Many of the artists who are working in modernist and postmodernist ways received post-secondary education at the Institute of American Indian Art (IAIA). Talks with Natasha Bonilla at the University of New Mexico and Karita Coffey, dean of Humanities at the College of Santa Fe and with Charles Dailey and Lloyd Kiva New at the Museum of the IAIA made me aware of alumni whose work I did not yet know.

The Heard Museum in Phoenix has provided ongoing exposure for contemporary artists with its biennial exhibitions of Indian contemporary artists, its visiting artists program, and a collection policy which includes contemporary art. Margaret Archuleta, the curator of fine arts at that institution, was generous with

her advice and time when I spent several days at the Heard Museum. The Heard's contemporary collection reinforced my feeling that the audiences for this work had been heretofore limited, and that a wider exposure of this vibrant and moving art needed to take place, particularly in the northeastern United States.

During the research on the exhibition, it had become increasingly clear to me that so many disservices had been done to Indian artists—past and present—by Anglo curators and patrons that, for perfectly valid reasons, I was not going to be accepted as the curator of an exhibition of American Indian artists. Through the good offices of Bernice Steinbaum, a New York dealer with an admirable record of representing Native American artists, I became acquainted with Jaune Quick-to-See Smith. She, more than any other Indian contemporary artist, has succeeded in bridging the gap between the metropolitan art world of New York and the Southwest where she lives and works. Besides being a successful exhibiting artist in the galleries of Arlene LewAllen (Santa Fe) and Bernice Steinbaum, she has been a visiting lecturer and artist at colleges and universities throughout the country, and her work is represented in major collections. Her personal artistic security has made it possible for her to be a mentor to dozens of younger artists, and she holds an unswerving loyalty to her mentors of an older generation.

We came to agreement on a land-based thematic focus. Native peoples see themselves as an extension of the natural world and do not compartmentalize the spiritual and the temporal aspects of their existences. They are uniquely qualified to comment artistically on the metaphysical, metaphorical, allegorical and political importance of the American land. The fate of the earth is finally coming to be a shared concern amongst people of all nations.

The conviction that this exhibition *needed* to be done was the only thing that kept me going until I met Sue Kaplan of Northern Telecom, Inc. who was captured by the project and the importance of recording the exhibition with a catalogue whose contributors were recognized in the art world. She convinced her colleagues in White Plains and Nashville (Brian P. Davis and Donald Caldwell, respectively) that underwriting this catalogue would be an important public service for their corporation. The University is extremely grateful for Northern Telecom's support, because an exhibition catalogue extends the life of the exhibition far beyond its temporal boundaries; furthermore, it is the only concrete record artists have of their exhibition histories.

Further encouragement came to the project with the news that Ruth Mayleas, a program officer at The Ford Foundation, had recommended the award of a major grant for general project support. This grant enables the presentation of the interpretative programs and special events so essential to enriching an exhibition's meaning for audiences of all ages.

The choice of essayists is one made with an eye toward presenting different views on Indian contemporary art. Rick Hill, a fine artist who has been active politically in the Iroquois world for many years, has now accepted a position that can help immensely to extend the influence and pedagogy of American Indian art. He is the director of the Museum of the Institute of American Indian Arts. The artist/writer Paul Brach has, in his own work, been deeply influenced by the landscape and light of the Southwest where he paints for several months each year. Lucy Lippard, an art historian and critic, has spent most of her professional life raising uncomfortable questions about the assumptions of Eurocentric art history and criticism. She writes both poetically and bitterly about the brilliance and the bias surrounding the contributions to American art history by artists who have been excluded from the magic circle where mainstream power and influence converge.

The staff members of the University Art Gallery have supported my preoccupation with this

exhibition for more than two years. Marijo Dougherty has graciously assumed the gallery leadership during my absences and has masterminded the plans for a series of interpretative programs. Joanne Lue served as initial editor, as secretary, and as liaison officer. Zheng Hu is responsible for the design of the Albany exhibition and the interpretative program materials. Kitty Wagner, a student in the graduate art program helped in countless ways during the early research. Jeanne Laiacona, a doctoral candidate at the University, did important research for the catalogue, the programs, and a successful grant proposal. The support of the Gallery Association of New York State has made it possible for the exhibition to tour far beyond the confines of New York State's capital.

NANCY H. LIDDLE
Director of the exhibition

For over eighteen years the Gallery Association has worked in collaboration with museums and galleries across New York State to organize and tour exhibitions to the broadest possible audiences. These exhibitions reflect the wide interests of Gallery Association's member institutions and the rich collections of the region's museums.

This publication and the exhibition it accompanies are the result of such a collaboration between the Gallery Association and the University Art Gallery, State University of New York at Albany. The involvement of many people has been critical to the success of this project. Nancy Liddle, director of the University Art Gallery, has been the organizer and guiding force behind the project. Jaune Quick-to-See Smith curated the exhibition. Important assistance in the development of the exhibition was also provided by Gallery Association staff including Ted Anderson, Helen Kebabian, Donna Lamb, Janet Rademacher, and Ann Resnick.

The Gallery Association is a nonprofit cooperative of more than 290 exhibiting institutions including museums, university galleries, historical societies, artists' cooperatives, art centers and libraries. The Gallery Association provides a variety of exhibition services including touring exhibits and film programs, art transport, exhibit design and fabrication, low-cost fine arts insurance, and technical assistance.

The Gallery Association received generous support for the exhibition tour from the John Ben Snow Memorial Trust, and we gratefully acknowledge its contribution. The Gallery Association would also like to thank its many other contributors, including the New York State Council on the Arts.

JACQUELINE DAY
Executive Director, Gallery Association of New York State, Inc., Hamilton, New York

THE RISE OF NEO-NATIVE EXPRESSION

Rick Hill

"Live and create," Alfred Youngman, a Cree painter, said in a 1973 catalogue *Quiet Triumph: Forty Years with the Institute of American Indian Arts*. His words sum up what art means for this current generation of artists of Indian ancestry. Indian artists of the modern era simply want to live their lives and make art about that life. However, there are debates in the art world that cloud our view of what is created and inhibit our understanding of art by Indians. These debates question the authenticity of Indian art and try to define artistic limits for artists of Indian ancestry.

Youngman attended IAIA from 1963 to 1968 when some creative magic was brought back to Indian art after several decades of control by teachers, scholars, curators and collectors. That magic was seen in the power of the individual to manifest a new vision of what it was like to be an Indian in a world that was preoccupied by the Cold War in Europe and distracted by the very hot war in Vietnam. But it was also a world in which Indians began to challenge the negative forces that had sought to destroy Indian realities. Indian Power sought to bring about dramatic changes. Art became a natural way to express that new kind of Indian activism.

Much has been written about the birth of the art studio program initiated by Dorothy Dunn at the Santa Fe Indian School in 1932 as a turning point in the development of the visual arts among Indians. Certainly Dunn's Indian students would later have a great impact on the visual arts among Indians. They included Allan Houser, Oscar Howe, Fred Kabotie, Pablita Verlarde, Pop Chalee, Joe Herrera, Ben Quintana, Quincy Tahoma, Andrew Tsinajinnie, Gerald Nailor and Harrison Begay. What they learned in her studio classroom was to become known as "traditional Indian painting," a misnomer that still has a stranglehold on our understanding of Indian art. In reality the Santa Fe Studio was a school of style taught in the Dunn classes, a style that benefited from a longer tradition of Indian use of color, shape, line and flattened perspective. The Dunn school of art allowed for obvious connections to traditional forms of painting, inspired by kiva painting, hide painting and pictographic imagery. The style was part of the larger-than-life heroic art that came out of that era as a reaction to the Great Depression. That style of art helped the Indians feel good about being Indian, helped to remind of the good old days when Indian life was "noble." Whatever the goals, it is clear that the early Studio approach was not to produce Indians as artists who would decide their own artistic path. It was just another form of paternalism with a dash of commercialism.

At Bacone Junior College, an Indian school in Muskogee, Oklahoma, another approach was underway. In 1935 an art program was started that would be directed by now famous Indian artists Acee Blue

Eagle, Woody Crumbo and Dick West, Sr. *Indian artists taught art to Indians.* Bacone would see the likes of Archie Black Owl, Fred Beaver, Blackbear Bosin, and Jerome Tiger. The Bacone program produced a school of art that honors the past, recalls the beauty of traditional culture and makes common scenes of the past very heroic and dramatic. This style defined Indian art in Oklahoma and became the focus of the Philbrook Art Center in Tulsa.

Although there had been a concentration of the development of painting in Arizona, New Mexico, and Oklahoma, there was also important activity in the Eastern United States and Canada. One of the artists was Ernest Smith, a Seneca self-taught painter who was hired by the Rochester Museum of Arts and Sciences from 1935 to 1941 to document Iroquois culture in his paintings. Funded by the federal Works Progress Administration, the artist produced over 200 works for the museum and continued to paint until his death in 1975. His influence is still felt among Iroquois artists.

The 1941 exhibit at the Museum of Modern Art, *Indian Art of the United States*, echoed a growing interest in art of Indians. In the catalogue, First Lady Eleanor Roosevelt wrote:

> In appraising the Indian's past and present achievements, we realize not only that
> his heritage constitutes part of the artistic and spiritual wealth of this country, but
> also that the Indian people of today have a contribution to make toward the
> America of the future. (Frederick Douglas and Rene D'Harnoncourt, *Indian Art of
> the United States*, 1941)

In the fifties, that future was in doubt. In 1953 the *Exhibition of Contemporary American Indian Painting* was shown at the National Gallery of Art in Washington, followed by an exhibition of Indian painting at the Art Institute of Chicago the following year. This period represents perhaps the high point in the acceptance of Indians as modern artists. But a restlessness emerged among Indian artists who wanted to express themselves in new ways.

A growing controversy had begun to plague the annual exhibition that the Philbrook Art Center initiated in 1946. In 1958 a work of Oscar Howe was rejected because it did not meet the criteria for "traditional" Indian style. Howe protested in a letter to Jeanne Snodgrass, the curator of the Annual:

> Are we to be held back forever with one phase of Indian painting that is the most
> common way? Are we to be herded like a bunch of sheep, with no right for
> individualism, dictated to as the Indian has always been, put on reservations and
> treated like a child, and only the White Man knows what is best for him…but one
> could easily turn to become a social protest painter. I only hope, the Art World
> will not be one more contributor to holding us in chains. (John Milton, *Oscar
> Howe*, Dillon Press, Minneapolis, 1976)

Modern Indian art which had been born out of a strange mixture of paternalism and resistance had now become controlled by curators and collectors of Indian art.

Again, the White Man came to the rescue. From 1960 to 1962 the Rockefeller Foundation funded the Indian Art Project at the University of Arizona that brought young Indian artists together with notable Indian artists such as Lloyd Kiva New and Charles Loloma. The experiment in Indian art that began in Arizona found a permanent home in Santa Fe with the establishment of the Institute of American Indian Art

in 1962. New became the first artistic director of IAIA and preached a new kind of Indian art, produced by a new kind of Indian. New and the art instructors assembled in Santa Fe began a unique experiment that allowed the students to explore, experiment, and express themselves in new ways.

By 1966, in recognition of the changing nature of Indian art, the Philbrook had added a "special category" in its annual exhibition. Indians had finally entered the art arena of self-expression, and the students at IAIA adapted to the new role with a level of creativity that continues to fuel the arts today.

From the beginning, Indian artists emerged from IAIA with a new sense of direction and power. Art by Indians would never be the same. Indians would never be the same. What came out of an Indian experiment in Santa Fe was a strong, vocal, creative artist who used Indian images to manifest a new destiny for Indians. No longer were Indians to be seen in their classic past, performing ancient tasks, living a "museum" kind of life. Instead, a new Indian emerged from the turbulent social upheaval of civil rights, Indian Power, Warriorism, and a break away from the confines of the assimilationist policies that earlier generations had faced. "The times they were a changin'" for Indians as well as the rest of America. The answer, however, was not "blowing in the wind"; it was found in the very lively art studios of Native American artists throughout the country.

This new approach to image-making among Indians continues today and represents the quality of Indian thinking. It represents the new Indian, the Neo-Native. If we need to call Indian art anything, it is Neo-Native Expressionism. It is the expression of what it means to be Indian. To some it is strong ties to the glorious past. To others it is a strong sense of an ongoing tribal identity. To others, it is the complex thoughts of the individual who is an Indian. It is many views, many realities, many voices. It is enough just to be able to understand and enjoy the power of Indian contemporary art, and not to be concerned about its "authenticity."

Art has always had a major role in Indian societies, allowing the people a chance to assess what is happening to them. To Indians, art remains something to look at and to contemplate, whether it is a kiva wall or a television screen. Art is made on purpose, to create a sense of beauty, to confirm beliefs and manifest individual thinking about the universe.

Indians express themselves through art because the social, political and religious education received at the hands of White Americans has not always allowed Indians to be themselves. Art for Indians is perhaps their last hope to retain their individuality in a country that promotes uniformity. Indians create art as an act of defiance to the attempt to subjugate Indians, as a protest to the attempt to assimilate Indians, and as an act of faith that somehow it is okay to be an Indian in the modern world. In fact, some Indian artists believe that it is preferable to be Indian.

Today, Indians exist in a diversity of contexts. Their art is evidence of that fact. There are no universal norms for Indian lives of today; there never were. The only commonality is that they are Indians, or more specifically, that they are not Caucasian, or African, or Asian. That context is not bound to the past, even though Indians may have special regard for the past. Indians will live in the future, not the past. In an interview, the late T.C. Cannon, considered by many the most talented Indian artist in the 1960s, wrote a statement about art as a student at IAIA:

> My finished works are the aftermath of a loving struggle with brush and surface—
> a heated exchange of ideas and a rendezvous of fact and visions, placed side by
> side, comprise a view of many from a vantage point that few of us have tried to
> induce so far. Had I wished to present the Indian—as some think he is and what

people want him to be——then it would have been total bewilderment on your part. As it is, you may wonder and ask why—but it is there for you to see or reject. Acceptance or rejection means nothing to me—acceptance is the goal of the mercantile agent—rejection most times is the unwanted reward of the fine artist.

I dream a great breadth of Indian art to develop that ranges through the whole region of our past, present and future. Something that doesn't lack the ultimate power that we possess. I am tired of Bambi-like deer paintings reproduced over and over—and I am tired of cartoon paintings of my people that grace mansions at a going rate of nothing and the same going rate for the artisan.

From the poisons and passions of technology arises a great force with which we as present day painters must deal. The mass media has forced so many fantasies and fortunes on us that our art must counteract, act, and superimpose this influence. The same group of contemporary Indian artists today have put their foot in the door without knocking. We are no prophets—we are merely potters, painters, and sculptors dealing with and in the latter 20th Century. (Manuscript in IAIA Museum, undated)

This seems to summarize the new directions in art by Indians. There can be a deep regard for the past, but people "live and create" in the present, and do it for the sake of the future. In looking back to the advent of the Studio situation associated with Dunn, it did not create modern art among Indians; it only allowed for more cross-fertilization of art by Indians. Individual artists had more influence upon each other. Teachers in the Studio had significant impact on style, direction and content; however, Indians are creative people—*right brained*, if you prefer. The need to express themselves is a traditional aspect of Indian lives, in the past and in the present; and it is perceived to continue long into the future.

What we see in contemporary art by Indians is not derived from passé mainstream art movements. It is truly unique. It is the Indian trying to express herself/himself as the Indian of today. Indian contemporary art is not anti-tribal or a denial of the past. Created by an individual of Indian ancestry who feels a new sense of urgency to express a relationship to the world around him/her, Indian art today is Neo-Native Expressionism. It deserves much respect.

RICK HILL
Museum director of the Institute of American Indian Arts, Santa Fe

Paul Brach

Almost all of the Native American artists in this exhibition were trained in art schools or university art departments. This means that they are fully aware of the art-making strategies of white culture. Unlike those Native American craftspersons who work in traditional modes, these artists must make difficult choices and adjustments to reconcile their identities (personal, tribal and pan-tribal) with mainstream "high art."

The challenge of such reconciliation is perhaps less daunting for Native Americans than for black artists whose tribal identities based on language and ritual were severed by white slavers. While blacks were cut off from their African roots, Native Americans inherit a traditional symbolic and decorative vocabulary that, while often weakened, remains unbroken in its duration.

In this exhibition, I find a wide range of personal solutions to the twin challenges of identity and aesthetics. By focusing on specific works, I can illuminate particular solutions without implying a qualitative judgement; as a card-carrying member of the white male establishment, I know how often "quality" is a code word for the exclusion of others.

Extremes of approach can be found in works by Dan Lomahaftewa (Hopi/Choctaw) and George Morrison (Chippewa). By chance, I know both of these artists. I remember George from the New York art world of the '50s and know the depth of his attachments to modernism. I met Dan when he was a graduate student at Arizona State University and I was a visiting artist. At that time we discussed the problem of traditional sources. Dan's imagery is explicitly Native. Disembodied Kachina figures float in a sky-space. I find it no accident that his images are so close to his Hopi heritage, since there is no tribe that is more culturally intact.

George Morrison's red-hued distant vistas have roots in Monet and Rothko. They express a tender reverence for the land, spread before us almost as it once appeared to the first Americans, the Natives. These landscapes express a yearning for a lost partnership with nature. George is able to choose the styles of his white artist-ancestors and transform them into an elegy to the dwelling place of his true ancestors.

Carm Little Turtle (Apache/Tarahumara) is one of the few realists in this group. I wonder why so few have followed this path. Could it be a reaction against all those trivialized paintings of "picturesque" Indians by white artists? More likely it is because abstract, or near abstract, forms in much tribal art rhyme with forms of the 20th century mainstream. In Little Turtle's hands, figuration is a powerful tool. *Bailerina y Tierra* is like a radically cropped photo, a compressed mixed-media image that extends by suggestion beyond its borders. Here dusky female legs pose on and against a small segment of southwestern terrain. Ironic cross-cultural signals come from the dancer's painted toenails and the fringed end of a sash that falls into the picture.

Ernie Pepion (Blackfeet) is also a realist, but he works in a funkier narrative style. *Artist and Assistants* can be seen as a take-off on Courbet's *The Studio*. In Pepion's case, his studio is the high prairie, his canvas is a stretched deer-hide, his gallery, the tepee behind him decorated with a running deer. His assistants are a dog and a buffalo. There is further irony. The artist is handicapped and works in his wheelchair. In case we wondered how he might have fared hunting buffalo or riding off to fight the Sioux and the Cheyenne, Pepion shows us in *Waiting For Me* that the wheelchair *is* his war pony.

Most of the artists choose abstraction. Conrad House (Navajo/Oneida) gives us a kaleidoscopic world in which fragments of form cluster, dissolve and recluster. *Index WA* owes a debt to Futurism, but this is not an homage to the machine, rather a creation myth where past and future, order and chaos are suspended in flux.

The environment evoked by Frank LaPena (Wintu/Nomtipom) is more stable and more domestic. In *New World Flower*, patches of cut paper make lively interruptions of the harmonious patterns. This collage embodies a spirit of play, a delicate tension between establishing visual rules and breaking them.

Kay WalkingStick (Cherokee) juxtaposes the nameable and the unnameable. In her drawing, *Is That You?*, she fits, side by side, two images of nature. On one side there is a drawing of rock faces, on the other an emblematic, fan-shaped fragment of a circle. We can balance these two images to read them as a dialogue between depiction and symbol. A fragment of the real equals a segment of the abstract whole.

Linda Lomahaftewa (Hopi/Choctaw) and Harry Fonseca (Nisenan Maidu) are among the artists who fuse figuration with mark-making. If two artists can comprise a school, I'll call this school *Petrographs in the Sky with Diamonds*. These new works come as a surprise. They represent departures from Lomahaftewa's earlier earthbound abstractions and Fonseca's *Coyote* paintings. Here the principles of microcosm and macrocosm seem to be at work. Patterns and images scratched on a rock can be symbolic mirrors of constellations and galaxies. Unlike WalkingStick's frontal twinning, Lomahaftewa and Fonseca fuse the earth and the heavens, the here and now, the long ago and the far away.

Duane Slick (Sac and Fox/Winnebago) works in a classic Abstract-Expressionist mode. His charcoal drawings, such as *Diagrams For a Landscape*, are about the action of finding his subject. Here process comes first. Erasures, cancellations and second thoughts all build up a patina of effort, with the final images rising to the surface. Such a process can be experienced as a metaphor for the destructive and regenerative forces of nature.

As artists we are all marginal to mainstream American culture. Native artists are doubly marginal, yet I find no expressions of alienation or despair in their work. Native identity is not used as a way to avoid the issues faced by other contemporary artists. The forms and stylistic strategies that these Native artists have assimilated from the white art world are but mere carriers of joyful, almost fierce feelings about themselves, their people and their land.

PAUL BRACH
Artist and critic

THE COLOR OF THE WIND[1]

Lucy R. Lippard

"You should understand / the way it was / back then / because it is the same / even now."— Leslie Marmon Silko [2]

"An Indian is a person whose roots are at least six feet into the earth."[3]

Our Land/Ourselves implies a dismissal of the boundaries between nature and culture. It reflects the complex and problematic relationship of Native American people not only to "their" land—the fragments of land they have been forced to "own"—but to their Land, a sense of place that transcends the often petty, often greedy, often destructive notions that rule the dominant culture. That such a relationship is elusive, enmired in less than admirable circumstances and lethally idealized myths, does not escape those Indians who must penetrate more than six feet of asphalt to find their own roots.

Some of these artists show the land, some show themselves, some show both, some appear to show neither, and somewhere in between is the spirit of what we are looking at, or looking for. This connection between self and place is a sensuous experience, a wordless experience, easier to paint and draw than to write about. In some of these works I can't find it, in others I sense it but can't describe it. Perhaps outsiders are not even supposed to see, or simply cannot "see" it in the Don Juan/ Carlos Casteñeda sense. "It" is the emptiness that fills under the right circumstances, the space between breaths where that which we call nature comes into her own.

But the fact remains that these artists are showing us their art, and between us we have to find our common ground. The cross-cultural process is a porous one, and something of a maze.[4] The word *Land* means many things within and among different cultures. The Land as a philosophical or religious concept differs from The Land as a patriotic concept, which differs in turn from land, which in our society means "property" and ownership, alien to Native tradition. Even the concept of Native sovereignty, being debated across North America, includes the belief that human law rises up from the land which, in turn, obeys the laws of the Creator, the All That Is, the Great Mother, or whatever name is chosen to connote the Unknowable. Land to most Native Americans is a force in itself, inseparable from all that inhabits it or is contained by it. In traditional Santa Clara Pueblo dances, the breath of the land is gathered in from the air, bringing with it authority and power. The Navajo say: "It was the wind / that gave them life / It is the wind / that comes out of our mouths now / that gives us life."[5]

Land is not a passive "view" or "vista" and there is no word for "landscape" in Native languages. As Patricia Clark Smith and Paula Gunn Allen have written,

the land is not only landscape as Anglo writers often think of it—arrangements of butte and bosque, mountain and river valley, light and cloud shadow. For American Indians the land encompasses butterfly and ant, man and woman, adobe wall and gourd vine, trout beneath the river water, rattler deep in his winter den, the North Star and the constellations, the flock of sandhill cranes flying too high to be seen against the sun. The land is Spider Woman's creation; it is the whole cosmos.[6]

For those who maintain tradition, there are innumerable small rituals that accompany daily life. "We Sioux spend a lot of time thinking about everyday things, which in our mind are mixed up with the spiritual," says Lakota shaman Lame Deer.

We see in the world around us many symbols that teach us the meaning of life…We see a lot that you no longer notice. We Indians live in a world of symbols and images where the spiritual and the commonplace are one. To you symbols are just words, spoken or written in a book. To us they are part of nature, part of ourselves, even little insects like ants and grasshoppers. We try to understand them not with the head but with the heart, and we need no more than a hint to give us the meaning.[7]

Visual art, like a walk through the woods, provides such hints. The relationship between general and specific in Native art is often unlike that in the dominant culture. Indian statements about the land, for instance, tend to be grandly metaphysical or intensely intimate and concrete, sometimes both in the same work. Ernie Pepion's *Artist and Assistants*, for instance, shows the artist casually at work, outdoors, in his wheelchair, accompanied by a black dog, a buffalo, and a deer that is painted on a nearby tipi. He paints on the painted skin of an animal, a reference to the material as well as spiritual assistance given humans by all our fellow participants in nature.

Many Indian artists bring to their images a "ritual understanding" of what is sensed and seen. So what "look like" landscapes to a white audience may in fact be permeated with an attitude, a way of seeing that is in fact far removed from European pictorialization. Contemporary art theorists tend to regard such ideas with some mistrust as "romanticizing" and "essentializing." This, however, is true primarily when these concepts are filtered through an alien belief system. Scepticism about theories from the outside that cast indigenous peoples into a mythical (and thereby controllable) past is justified. But it is countered by the balance, beauty and harmony of such beliefs within their own context when they are relatively unsullied by paternalism and commercialism. And external responses to such holistic, integratory concepts must also be seen in the light of a sense of their absence in this society. It is ironic that the sense of loss of connection to the earth and spiritual connections to nature has focused upon the Native American community, which has been forced to maintain its diminished visions against the odds and a devastating American Dream. As Euro-Americans suddenly "discover" the earth, Native Americans continue the centuries-old battle for their land, water, and cultural rights. Today political tensions are rising, catalyzed by nuclear intrusions, pollution, disproportionate cancer rates, and virtual wars over hunting, fishing, timber and range.

While history apparently seems less urgent to a dominant culture surrounded by its own mementos, for many Native American artists the past is present in the present and the future. It is recalled with nostalgia and pride, bitterness and anger. Every artist who calls her or himself Indian must deal with history, time, memory, and the preconceptions brought into the present from the past, both by other Indians and by others.

As Cherokee poet and sculptor Jimmie Durham has said:

> To be an American Indian artist is quite possibly to be more sophisticated and
> universal than many white artists can manage, for what should be obvious
> reasons....It would be impossible, and I think immoral, to attempt to discuss
> American Indian art sensibly without making political realities central.[8]

Corwin Clairmont's "Grandfather Rock" series recalls specific historic events and encircles the bland and often untruthful official markers that commemorate them. "Grandfather Rock Remembers the two Peigan Indian warriors killed by the Lewis and Clark Expedition, July 26, 1806," reads his inscription on one piece, while the other quotes stirring words of resistance by Nez Perce Chief Joseph. The combination of photographs and a shield-like circle of printed Indian figures with pendant feathers conveys a double time, the past that is always with us that haunts Indian people, while scales and compass suggest the imposition of alien "measures" on the land. A very different reclamation of history is being activated by Native people themselves at restored archaeological sites like that at the Blood Reserve in Canada and the Seneca historical site directed by artist Peter Jemison at Ganondagan in northern New York. Jemison's art often "draws" attention to these issues by juxtaposing found (xeroxed) and created images.

In Ernie Pepion's *The Gift* —a gentle, but incisive political statement—the measures imposed are even more threatening. Landscape and symbols are double-edged and double-timed. An ancient stone circle, or medicine wheel, is broken by a line of stakes as sacred land is developed for construction, as a factory pollutes the air in the background. A Pendleton blanket hanging over a high tree branch stands both for the traditional Blackfeet gift hung out for the sun, and for sacrifice—in this case the involuntary sacrifice of the land. This drawing might refer to a classic case of public incomprehension about the land and its religious value, illustrated by the Forest Service's desire to "upgrade" the site of a great ancient stone monument—the Medicine Wheel in Wyoming's Bighorn National Forest. They plan to build a road, a parking lot, a visitors' center and a viewing platform to "enhance" this (at least) thousand-year-old sacred structure aligned to celestial events, which is still a center of worship for a number of western tribes.[9] Sacred sites—which may look like "nowhere" to an outsider—are the wellsprings of many Native religions. They have been compared to churches and temples, but the razing of a church is far less destructive to the beliefs enacted there than the bulldozing, development or inaccessibility to a landscape feature that is imbued with and inseparable from that faith.[10]

The issues of land rights and cultural rights underlie many of the images in this show. They are perceived by Indian elders as moral issues rather than the "business" or economic issues cited by their corporate and governmental adversaries. There is, for instance, the increasing national interest in the restoration of Indian place names, which can be keys to cultural survival and serve simultaneously as a "mnemonic peg on which to hang a social history."[11] One paradoxical by-product of the ensuing debates around remapping is the fact that places are sometimes so spiritually embedded in beliefs that to give away their names would be a betrayal of sacred secrets. This too is incomprehensible to those who usually perceive place names as honoring not the land, but those who have conquered it. At times the Europeans after whom places are named present in themselves a tremendous insult or painful memory to the original inhabitants.[12]

Jean LaMarr subtly comments on such intrusions by placing her contemporary Indian protagonists in abstracted spaces that are simultaneously comforting and dangerous—local landscapes and glowering skies

across which scream fighter planes and missiles, disturbing the indigenous peace; on the land itself, barbed wire separates "some kind of Buckaroo" from the viewer, "fenced off" on a reservation as though imprisoned or, perhaps, protected. Brad Bonaparte offers two lands—close and distant, at once landscape and map (resembling Central America), for the marching soldiers in his ominous, acridly colored *Suppressing the Revolution.* Since Bonaparte is an Akwesasne Mohawk deeply involved with tribal education, this piece takes on a weight of topical relevance, given Mohawk resistance to the use of sacred lands for a golf course at Oka, Quebec.

There is also a great deal of activity in Indian communities to combat the "celebrations" of the 1992 Quincentennial of Columbus' accidental invasion of the Americas. One of the leaders of this movement is the Submuloc Society, conceived by Corwin Clairmont and continued by him and by Susan and Kathryn Stewart, all of MICA (Montana Indian Contemporary Art) and all represented in this exhibition. A reversal of Columbus' name is symbolic of a more inclusive reversal and, ideally, the instigation of a "Post Columbian" era, a 500 years free of the pain, greed, and deception that have marked the Columbian era.

Perhaps more Native American artists have not taken up this aspect of *Our Land/Ourselves* because of the steadfast tradition of healing wounds with beauty and humor rather than with direct protest. The bitterly satirical vein of Indian humor is for the most part absent from the work in this show. Most of these artists concentrate on the positive aspects of an unthreatened land (although there is no longer any such thing), or on land as an eternal Mother Earth. This constitutes a form of prayerful thinking. For the Navajo, "the Landscape is beautiful by definition because the Holy People designed it to be a beautiful, harmonious, happy and healthy place. For beauty to be maintained it must be expressed in actions such as the creation of art...The Navajo concept of beauty is an extremely active one."[13] Navajo Conrad House's abstract works combine turbulence and stasis. There is nothing in them that suggests the outer look of the vast, serene Navajo domain. Faces and a few other recognizable forms emerge at times from the swirling or intricately patterned surfaces that express the hidden and invisible energies in the land.

House's work, and the dynamic arcs and bands of Susan Stewart's "Awé" series, exemplify this inner view of nature. Stewart thrusts the sedate, meticulous motifs of traditional art into a careening space that no longer defines, but incorporates them. Kay WalkingStick, on the other hand, juxtaposes rather than merges the inner and outer views. A recognizable cascade, or rocky hill, is paired with an abstract form that appears to enter the substance depicted and offer a more ethereal view.

In the active sense, the word *land* is also a verb, meaning to "land some place," to be "grounded," to have a "landbase," which George Longfish and Joan Randall have defined as "the interwoven aspects of place, history, culture, physiology, a people and their sense of themselves and their spirituality."[14] N. Scott Momaday has described the relationship between a landbased person and the land: "The events of one's life take place, *take place*...they have meaning in relation to the things around them." Recalling his childhood at Jemez, he says that as people exist in a landscape, their existence is indivisible from it: "I placed my shadow there in the hills, my voice in the wind that ran there, in those old mornings and afternoons and evenings." George Morrison's glowing, transcendent "Horizons" series is inspired by the site of his studio in Red Rock, Minnesota, in the Grand Portage of Lake Superior where "the enigma of the horizon" is his constant companion. Earth and sky meet, merge, disperse like the changing lights of a Northern day. The sky, Morrison has said, has a life of its own, constantly moving and changing "as part of the phenomena of nature that relate to something that we can't even see, which is the wind that has sound and has a presence of its own."[15]

An assumption of the mutual all-pervasiveness of all things underlies much that we see in this show.

Landscape elements in Indian art, both traditional and modernist, are often represented symbolically rather than naturalistically. While they may appear as "abstractions" in the art world context, they are in fact as concrete and "real" (or more so) than the illusions of "realist " painting. Neil Parsons brings landscape and natural detail—the close and the far—together through collage. Inspired by the traditional decorative abstractions of American Plains Indians, his spontaneous brushwork bears little stylistic resemblance to his sources, yet "the same endless expanses of grass, the same wildflower and mountain lakes which inspired the abstract art of my forefathers continue to be inspirational for me." [16] The collaged floral additions suggest the experience of discovering a brilliantly colorful flower or a greening tree as one walks through rocky mountains with their own muted colors.

In Mario Martinez's work, natural and human-made forms become each other. He is always inspired by nature, especially flowers, which to the Yaqui are "the most potent representation of the natural world. …The flower forms in his work loom large, as though we, the viewers, were the size of insects." [17] Duane Slick's powerful ovals of paint might be wombs, masks, or seed pods, the movements of animals, or all and none of these. They are the explosive patterns of thought about the land rather than any depicted feature. Jeffrey Chapman's *Inside Information* juxtaposes on a window frame the handprints ubiquitous in rock art with deer tracks as a metaphor for inherited knowledge.

Joe Feddersen has combined distance and intimacy by combining, as so many of these artists do, the old and the new. He constructs his mountain/head (self portrait/landscape) photographic images on a computer. The strange, pale textures provide a tactile flatness that recalls traditional imagery, and at the same time offers a curious atmospheric surface that suggests depth as well as weather patterns. Jack Malotte also refers to computerized nature in his prints. The present pops out at the viewer in image fragments set against the monumental wholes of a mountain landscape recalling the geological past.

Some Indian artists depict everyday life in such intricate detail that these images are in turn seen as "naive" rather than "realistic." When contemporary modernists use their tribal symbols and colors, they may in turn appear "abstract" (i.e. individually determined) to most audiences, including many Native Americans. Similarly "maps" of familiar and/or mythological landscapes will appear as "individualist" to the uninitiated. For those still deeply encultured, process may be far more important than product, and use, meaning, or subtle associations with place and raw materials may endow a work with qualities that escape the untutored. [18] The modernist Pueblo artist Helen Hardin, daughter of the well known traditional artist Pablita Velarde, distinguished between traditional painting—which "usually tells a story….depicts a scene, tells what is happening there"—and contemporary art, which "leaves you with a feeling rather than a story." [19] Few of the artists in this show paint a recognizable local landscape, preferring to focus on essences rather than appearances. But, like Pepion, Robert Gopher (in *Leaving Crow Country*) and Alex Jacobs (*Jake Sunshine by the River*) introduce a lone figure who seems to exist with and within the specific landscape. "Land" may also not connote a specific place, but a communal journey that could be voluntary (nomadic) or involuntary (the imposed diaspora). As Flathead painter Jaune Quick-to-See Smith has written: "I place my markings onto a framework in homage to the ancient travois: in a sense, piling my dreams on for a journey across the land." [20]

For many artists, it is the close view of nature that bursts into an expansive scale. Kathryn Stewart's images of natural forces are serene, but sparkling with creature vitality, while Marty Avrett paints the stylized land as though it were a stage set, a night silence waiting to be brought to life. Phil Young's "Excavated Memories" series concentrates on "erosion" as a physical fact and as a metaphor. He brings us as close to his

handmade paper surfaces, to micro/macrocosmic rock walls and crevasses, as we might come to a lover. P.Y. Minthorn's dazzling black and white monotypes — a series called "The Land Counting Itself"— also explode with the internal truths of canyon walls, boulders, sky over earth.

Ancient petroglyphs and rock art have provided a special inspiration. They are a lost language that nevertheless speaks to the descendants of their makers, offering a great reservoir of meaning for contemporary Indian art. The Hopi are the most direct descendants of the Anasazi who made much of the Southwestern rock art. Linda Lomahaftewa's petroglyph figures are raised from the dead, and from the rock, to leap and dance in her own pictorial space. Her imagery comes from

> being Hopi and remembering shapes and colors from ceremonies and from the landscape. ...My Dad told us that whenever you're doing your work, you should always pray and sing a song because things come out better that way. So I think about this while I work. For me, art is not just slopping paint around, but something very sacred and spiritual.[21]

Dan Lomahaftewa brings his rock art figures to life in a different manner, lifting them from their dark surfaces and repainting them against a veil of palely colored light or sky. He recalls how his imagination was stirred when he recognized in the petroglyphs images he had personally experienced in ceremonies, stories and songs on the Hopi mesas where he lived as a boy:

> The Katchina type figure in some panels plays a major role not only in their composition, but also in their creation, helping the people in their guardianship of the earth.[22]

Harry Fonseca has chosen for his "Stone Poems" series the mysterious warrior or shamanistic petroglyphs from the Coso Range in the Mojave Desert. They are located within the Naval Weapons Testing Center, where they guard the land against this new incursion. He renders the impressive figures in an incandescent blue, white and black, touching them with sparkling bursts of light that illuminate them from both within and without. "I was impressed with the space around them," said Fonseca. "There were no boundaries—there's a real freedom to them."[23]

The "decorative" aspect of Indian art tends to be misunderstood. Several artists mention Klee, Miró, and Kandinsky as influences. Perhaps not coincidentally, these artists' styles demonstrate an affinity with Native traditions. (Newman, Still, and Pollock were deeply influenced by American Indian art, but they do not seem in turn to have left much of a trace on contemporary Indian artists.) George Longfish's "War Shirts" refer to the land, its symbols, and its history while keeping one foot on more ambiguous turf. He walks his tightrope between modernist abstraction and an eccentric Indian content with a gentle sarcasm, engendered in that space "where you receive and transmit energy."[24] Frank LaPena's colorful, schematic *New World Flower* shares the shallow space of traditional symbols but amplifies the sense of "blooming" past the specific. LaPena sees no conflict between the traditional and the modern, "what I do and who I am. What misunderstanding there is comes from others who do not understand the importance of continuity and the value of changing forms, while maintaining the essence of my symbolism."[25]

Photography presents a different challenge to those standing their own ground and also trying to bridge the artistic gaps between communities. Because its history in Native America is one of exploitation and sacrilege, few Native artists have been attracted to it. Now they are setting out to reinvent it from the inside.

Jolene Rickard's montages and juxtapositions of imagery from the Tuscarora reservation are deliberately hermetic, offering double meanings to her own and other people. In *Sisters*, a triple portrait, she allies her horizontal self (in color) with two female spirits of corn (in black and white) and thereby with the land. Carm Little Turtle's photographs come upon life from unexpected angles, often looking down, toward the earth, where her women's brightly painted toes rest, or where cowboy boots tread the land. She crops her figures "so that you see parts of their bodies but not their faces, in order to suggest movement or solitary journeys that are dreamy, conceptual narratives."[26]

A distant view of the land is taken by photographer Paul Koch whose black and white Western landscapes sing with light and space. Koch is a photographer, an architectural artist (in 1976-79 he built a passive solar-heated survival shelter from recycled materials on Cape Cod), a writer and publisher who lists his interests as: "Conservation. Functionalism. The Golden Section. Archeoastronomy. Devices without moving parts."[27] Jeffrey Thomas' photographs bridge the urban and rural landscapes. Dancers in full regalia walk a city street and a forlorn faceless man walks by a pawn shop. Paired with these images, those depicting a pile of corn and farm implements in a winter wood suggest what there is for the dancers to return to, and what for some city wanderers may have been lost forever.

ça ça ça

Paula Gunn Allen insists that everyone look at American Indian art "from the point of view of its people."[28] But that's easier said than done. To do so a white critic must know more than any of us know, as well as try to submerge her/his own culture and step into the hybrid state where many Native people already live. So much has been written about Indian art, and yet sometimes it seems as though nothing has been said yet, that nothing can be said, that the contradictions are overwhelming burdens on the artists and the viewers, caught as we both are in the vise of a racist, narrow-minded, unspiritual, apolitical society.

Introducing another exhibition of contemporary Indian art a few years ago, Longfish and Randall cited the "contradictions in Indian Territory" and asked viewers to "suspend what they 'know' to be Indian art," to allow "that feeling of uncertainty which usually accompanies new experiences" to accompany them. The artists, they note, assume they are Indian; "they do not concern themselves with having their art 'look' Indian." Speaking to the artists themselves, Longfish and Randall wrote:

> Stand on the back of the Turtle, our mother, and look at the land and wonder
> what it would have been like if Columbus would have been successful in his
> pursuit of India and avoided the eastern shore of this continent. Wipe your Indian
> hands on your Levi jeans, get into your Toyota pick-up. Throw in a tape of
> Mozart, Led Zeppelin or ceremonial Sioux songs; then throw back your head and
> laugh—you are a survivor of a colonized people. Paint what you see, sculpt what
> you feel, and stay amused.[29]

For all their references to and reverence for tradition, these artists are making new artifacts to replace those that have been stolen from them and placed disrespectfully in alien contexts. They also replace outworn notions of what Indian art is, what Indians are, and, reciprocally, what we the Others are. In the process, they are healing some wounds and following the circle around again. A Plains Indian looking at

a dazzlingly modernist pair of Carrier beaded moccasins that might have been painted by the French Cubist colorist Robert Delaunay, told Ralph T. Coe admiringly, "It looks like they really could reinvent the wheel."[30]

LUCY R. LIPPARD
Writer and activist

ENDNOTES

[1] George Morrison, in Edwin L. Wade and Rennard Strickland, eds., *Magic Images*, Tulsa: Philbrook Art Center, 1981, p. 86.

[2] Leslie Marmon Silko, *Storyteller*, New York: Seaver, 1981, p. 94.

[3] Gerald R. McMaster quoting an anonymous friend, in *Why Do You Call Us Indians?*, Gettysburg, PA: Gettysburg College Art Gallery, 1990, p. 6.

[4] I have not found its center yet, despite having spent several years writing a book on the subject.

[5] *American Indian Art: Form and Tradition*, Minneapolis: Walker Art Center, Indian Art Association, Minneapolis Institute of Arts, 1972, p. 19.

[6] Patricia Clark Smith and Paula Gunn Allen, "Earthly Relations, Carnal Knowledge," in Vera Norwood and Janice Monk, eds., *The Desert is No Lady*, New Haven: Yale University, 1987, p. 176.

[7] Quoted in Paula Gunn Allen, *The Sacred Hoop*, Boston: Beacon Press, 1986, p. 69.

[8] Jimmie Durham, in *Ni' Go Tlunh A Doh Ka*, Old Westbury: NY, Amelie A. Wallace Gallery, 1986, p. 1.

[9] Outside of this exhibition, Jimmie Durham, Edgar Heap of Birds, Jaune Quick-to-See Smith, James Luna, Ron Noganosh, Joane Cardinal-Shubert, Jane Ash Poitras, and a number of other Native artists in the U.S. and Canada have also addressed the issue of land rights and sacred sites.

[10] In the disastrous legal case Lyng v. Northwest Indian Cemetery, the Supreme Court ruled in 1988 that the law did not cover protection of sacred sites, thereby denying Indian peoples their First Amendment rights to freedom of worship.

[11] Keith Basso, *New York Times*, Aug. 4, 1988.

[12] Navajo students have petitioned to change the name of Washington Pass on the Navajo Reservation because it is named after a U.S. soldier who murdered the peaceful leader Narbona in 1848; the suggested new name is Narbona Pass. At the University of Colorado in Boulder, after more than a decade of protest, the Oyate Indian students' club and its supporters succeeded in changing the name of a dormitory from Nichols Hall to Cheyenne-Arapaho Hall. Nichols, a founder of the university, had also been an enthusiastic participant in the infamous Sand Creek massacre.

[13] Nancy J. Parezo, Kelley A. Hays, and Barbara F. Slivac, "The Mind's Road: Southwestern and Indian Women's Art," in *The Desert is No Lady*, p. 159.

[14] George Longfish and Joan Randall, "Landscape, Landbase, and Environment," 1984 typescript.

[15] George Morrison, *Standing in the Northern Lights*, St. Paul: Minnesota Museum of Art, 1990, p. 32.

[16] Neil Parsons, *Contemporary Native American Art*, Stillwater: Oklahoma State University, 1983, n.p.

[17] Abby Wasserman, "An Artist's Profile: Mario Martinez." *Native Vision* 4, no. 4. San Francisco: American Indian Contemporary Art,1987, n.p.

[18] Parezo et al., *The Desert Is No Lady*, p. 169-70.

[19] Helen Hardin, quoted by Lou Ann Faris Culley in *American Indian Art Magazine*, Summer 1979, p. 69.

[20] Jaune Quick-to-See Smith, quoted in Gerald Vizenor, *Earthdivers*, Minneapolis: University of Minnesota Press, 1981, p. xxii.

[21] Linda Lomahaftewa, in *Women of Sweetgrass, Cedar and Sage,* New York: American Indian Community House Gallery, 1985, n.p.

[22] Dan Lomahaftewa, unpublished statement.

[23] Harry Fonseca, quoted by Harry Roche, *San Francisco Bay Guardian,* Feb. 21, 1990.

[24] George Longfish interviewed by Kay WalkingStick, "Like a Longfish Out of Water," *Northeast Indian Quarterly,* Fall, 1989, p. 22.

[25] Frank LaPena, *The Extension of Tradition,* Sacramento: Crocker Art Museum, 1985, p. 64.

[26] Carm Little Turtle, *Women of Sweetgrass, Cedar and Sage,* n.p.

[27] Paul Koch, unpublished statement.

[28] Paula Gunn Allen, *The Sacred Hoop,* p. 75.

[29] George Longfish and Joan Randall, introduction to *Contemporary Native American Art,* Stillwater: Oklahoma State University, 1984, n.p.

[30] Quoted in Ralph T. Coe, *Lost and Found Traditions,* Seattle: University of Washington Press, 1986, p. 251.

LIST OF ARTISTS:

MARTY AVRETT

Coushatta/Choctaw/Cherokee

BORN: 1942, Dallas, Texas
EDUCATION: B.F.A., M.F.A.,
San Francisco Art Institute
RESIDENCE: Stillwater,
Oklahoma

SELECTED RECENT EXHIBITIONS: *Recent Paintings* (solo),
Oklahoma Art Center, Oklahoma City, 1989; *Recent
Paintings* (solo), Galeria San Miguel II, San Miguel de
Allende, Guanajuato, Mexico, 1988; *Recent Generations:
Native American Art 1950-1987*, The Heard Museum,
Phoenix, 1987; *Color, Form, Emergence*, American Indian
Contemporary Arts, San Francisco, 1986; *Second Biennial
Invitational*, The Heard Museum, 1985; *Contemporary
Native American Art* (traveling), Oklahoma State
University, Stillwater, 1984.
PROFESSIONAL AFFILIATIONS: Faculty, Oklahoma State
University

Calvario Memory
1990
Oil on paper
21 7/16 x 28 3/4"

Huichol Stick
1990
Oil on paper
21 7/16 x 28 3/4"

Marcella's Light
1990
Oil on paper
21 1/8 x 29"

Huicholsong
1990
Oil on paper
21 3/8 x 28 3/4"

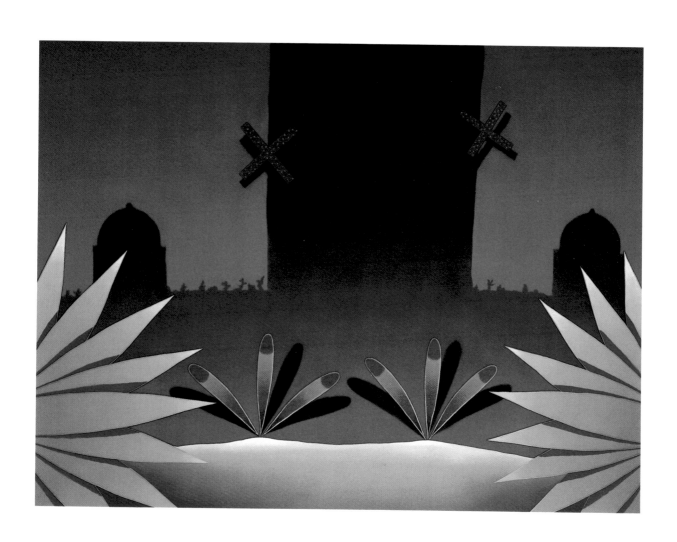

ARAWARATHE (BRAD) BONAPARTE
Akwesasne Mohawk

BORN: 1969, Syracuse, New York

EDUCATION: Humber School of Applied Arts and Technology, Toronto; Toronto School of Fine Arts

RESIDENCE: Bombay, New York

SELECTED RECENT EXHIBITIONS: Steinman Festival of the Arts, St. Lawrence University, Canton, NY, 1990; Solo exhibition, Ballard Mill Art Gallery, Malone, NY, 1989; Akwesasne Museum Community Show, Hogansburg, NY, 1988; Akwesasne Library and Museum, 1987.

PROFESSIONAL AFFILIATIONS: Media Resource Specialist, North American Indian Traveling College, Cornwall Island, Ontario

Suppressing the Revolution
1984
Screenprint
19 ¼ x 24 ⅜"

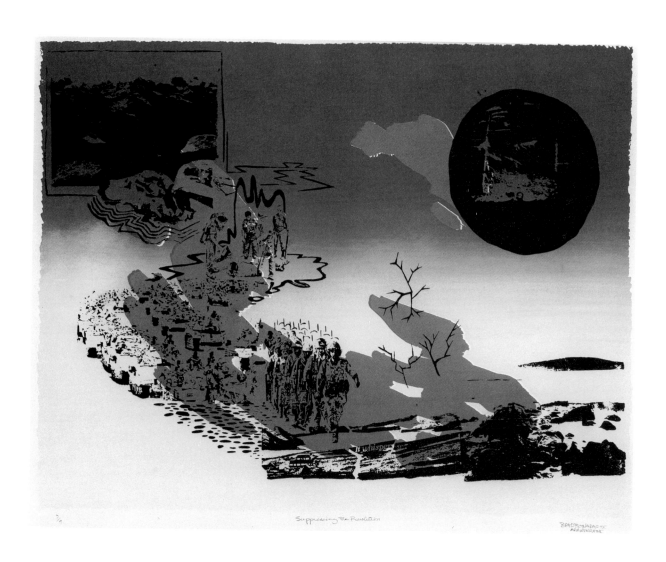

Suppressing the Revolution

BRADFORD NAPARTS
APAUNIRAINE

JEFFREY CHAPMAN
Chippewa

BORN: 1958, Minneapolis, Minnesota
EDUCATION: B.F.A., Minneapolis College of Art and Design
RESIDENCE: Minneapolis, Minnesota

SELECTED RECENT EXHIBITIONS: *Native American Expressions of Surrealism*, Sacred Circle Gallery, Seattle, WA, 1989; *The Elders Show*, Minneapolis Bell Museum, University of Minnesota, 1989; Group exhibition, Howard University, Alexandria, VA, 1988; Solo exhibition, Raven Gallery, Minneapolis, 1986, 1984; *Paintings by Jeffrey Chapman*, Southern Plains Museum, Anadarko, OK, 1986; Solo exhibition, Blandin Foundation, Grand Rapids, MN, 1986.
PROFESSIONAL AFFILIATIONS: Art Panel, Native American Arts Task Force Commission, Minneapolis; Traditional Flute Carver; Raven Gallery, Minneapolis; Northern Plains Gallery, White Bear Lake, MN

Ya Can't See the Forest through the Trees
1990
Watercolor
27 ¾ x 20 ¼"

Inside Information
1989
Watercolor
27 ¾ x 20 ¼"
Anonymous lender

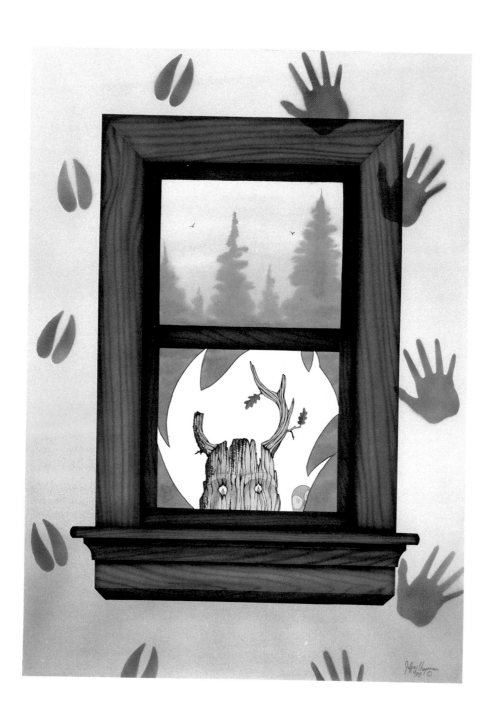

CORWIN CLAIRMONT
Salish-Kootenai

GRANDFATHER ROCK
SERIES **II**

BORN: 1947
EDUCATION: B.A., Montana
State University, Bozeman;
M.F.A., California State
University, Los Angeles
RESIDENCE: Pablo,
Montana

SELECTED RECENT EXHIBITIONS: *Hammer, Nail and Brush*,
Centro Cultural de la Raza, Balboa Park, San Diego, 1990;
Environmental Impact Statements, Missoula Museum of the
Arts, Missoula, MT, 1990; *Introductions: Contemporary
American Indian Art and Emerging Artists* (traveling),
Montana State University, 1990; *Circle Way: Art of Native
Americans* (traveling), Cambridge Multicultural Arts
Center, Cambridge, MA, 1989; *Four Sacred Mountains:
Color, Form and Abstraction* (traveling), Arizona Arts
Commission, 1988.
PROFESSIONAL AFFILIATIONS: Administrative Staff, Salish-
Kootenai College, MT; Montana American Indian
Committee for Higher Education

Grandfather Rock Series II
1990
Mixed media
30 ⅛ x 22 ¼"

Grandfather Rock Series I
1990
Mixed media
29 ¾ x 22 1/16"

24

25

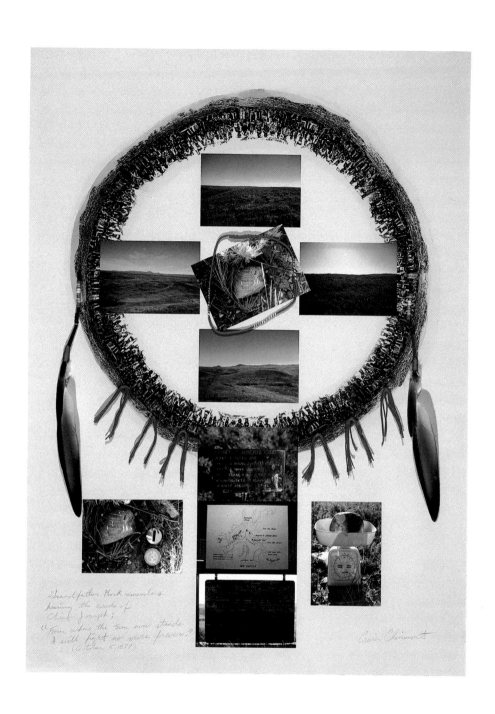

Grandfather Rock remembers
hearing the words of
Chief Joseph:
("From where the sun now stands
I will fight no more forever."
(October 5 1877)

Aaron Clairmont

JOE FEDDERSEN
Colville

BORN: 1953, Omak,
Washington
EDUCATION: B.F.A.,
University of Washington,
Seattle; M.F.A., University
of Wisconsin, Madison
RESIDENCE: Shelton,
Washington

SELECTED RECENT EXHIBITIONS: *Circle Way: Art of Native Americans* (traveling), Cambridge Multicultural Arts Center, Cambridge, MA, 1989; *Four Sacred Mountains: Color, Form and Abstraction* (traveling), Arizona Arts Commission, 1988; *Third Biennial Invitational*, The Heard Museum, Phoenix, 1987; *Joe Feddersen: Photographs*, Galleria Posada, Sacramento, CA, 1987; *New Directions*, Northwest Oregon Art Institute, Portland, OR, 1987; *Feddersen*, R.C. Gorman Museum, University of California, Davis, 1986.
PROFESSIONAL AFFILIATIONS: Faculty, Evergreen State College, Olympia, WA

Red Web
1989
Computer print
5 ⅝ x 8"

Fog
1989
Computer print
5 ⅝ x 8"

Dusk
1989
Computer print
5 ⅝ x 8"

Red Chevrons
1989
Computer print
5 ⅝ x 8"

Liquid Darkness
1989
Computer print
5 ⅝ x 8"

Threshold
1989
Computer print
5 ⅝ x 8"

HARRY FONSECA
Nisenan Maidu

BORN: 1946, Sacramento, California

EDUCATION: Sacramento City College; California State University, Sacramento

RESIDENCE: Sacramento, California

SELECTED RECENT EXHIBITIONS: *Stone Poems: New Paintings by Harry Fonseca,* Southwest Museum, Los Angeles, 1989; *Coyote: A Myth in the Making* (solo, traveling), Los Angeles Museum of Natural History. Also shown at Joslyn Art Museum, Omaha, NE; Taylor Museum, Colorado Springs, CO; Fresno Metropolitan Museum, Fresno, CA; The Oakland Museum, Oakland, CA; Millicent Rogers Museum, Taos, NM; National Museum of Natural History, Smithsonian Institution, Washington; The Field Museum of Natural History, Chicago (1986 - 1989); *Cowboys and Indians: Common Ground,* Boca Raton Museum of Art, Boca Raton, FL, 1985.

PROFESSIONAL AFFILIATIONS: Founder, Quail Plume Gallery, Albuquerque, NM; Elaine Horwitch, Santa Fe, NM and Scottsdale, AZ; Stremmel Gallery, Reno, NV

Nocturne
1990
Mixed media
30 x 22 $7/16$"

Nocturne
1990
Mixed media
30 x 22 $1/16$"

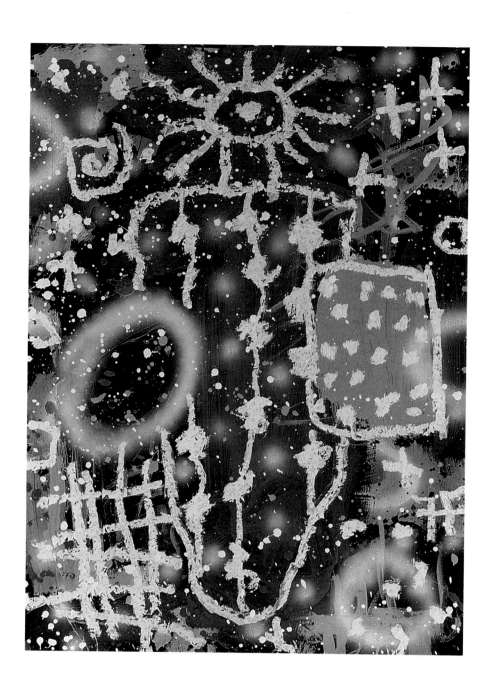

BORN: 1951, Fort Belknap, Montana

EDUCATION: University of Wisconsin, Milwaukee; B.A., Eastern Montana College, Billings

RESIDENCE: Rocky Boy, Montana

SELECTED RECENT EXHIBITIONS: *Introductions: Contemporary American Indian Art and Emerging Artists* (traveling), Montana State University, Bozeman, 1990; Solo exhibition, Eastern Montana College, 1989; *Circle Way: Art of Native Americans* (traveling), Cambridge Multicultural Arts Center, Cambridge, MA, 1989; *Ten Views,* Montana Institute of the Arts, Billings, 1988.

PROFESSIONAL AFFILIATIONS: Faculty, Rocky Boy School System

Dancer of Life
1990
Acrylic/oil
22 ¾ x 29 ⅜"

Leaving Crow Country
1990
Acrylic/oil
29 ¾ x 22"

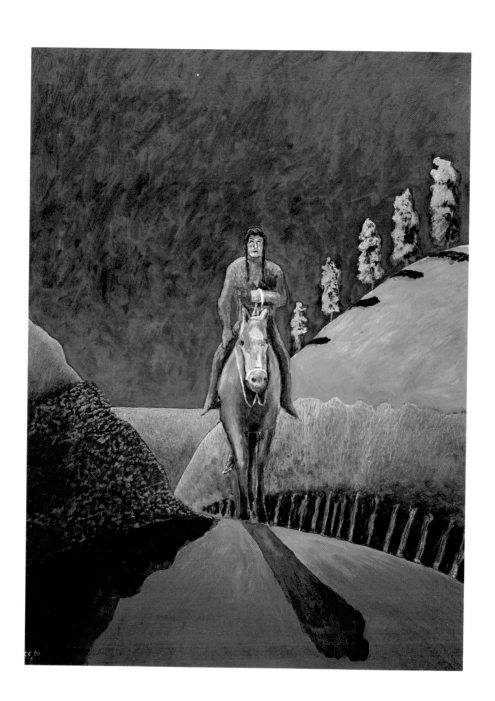

Navajo/Oneida

BORN: 1956, Rehoboth,
New Mexico
EDUCATION: B.F.A.,
University of New Mexico,
Albuquerque; M.F.A.,
University of Oregon,
Eugene
RESIDENCE: Thoreau,
New Mexico

SELECTED RECENT EXHIBITIONS: *Tradition and Spirit*, Maryhill
Museum of Art, Maryhill , WA, 1990; *Indicator Species* (solo),
American Indian Contemporary Arts, San Francisco, 1988;
Eight Native American Artists, Fort Wayne Museum of Art,
Fort Wayne, IN, 1987; *What is Native American Art?*,
Philbrook Art Center, Tulsa, OK, 1986; Solo exhibition,
Museum of the Plains Indian, Browning, MT, 1986.
PROFESSIONAL AFFILIATIONS: Galeria Capistrano, Santa Fe,
NM and San Juan Capistrano, CA; American West, Chicago

Paseo Del Norte
1989
Pastel
22 ¼ x 30 ⅛"

Index, WA
1989
Pencil/watercolor
14 ⅞ x 22"

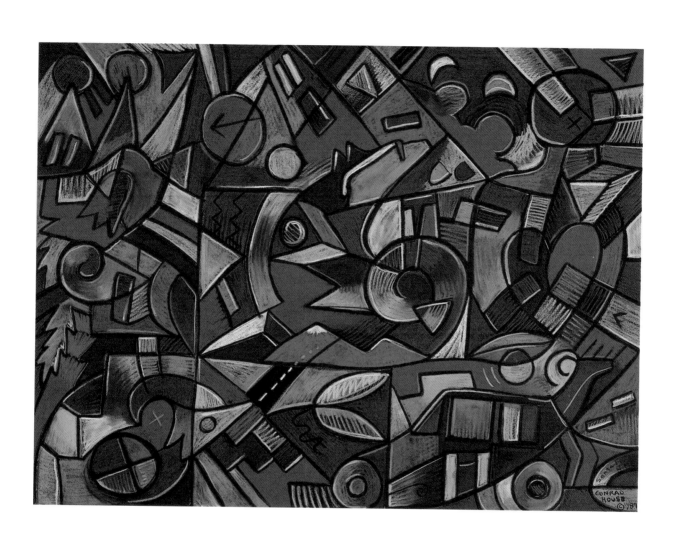

BORN: 1953, Hogansburg, New York

EDUCATION: A.F.A., Institute of American Indian Arts, Santa Fe, New Mexico; B.F.A., Kansas City Art Institute, Kansas City, Missouri

RESIDENCE: Roosevelt, New York

SELECTED RECENT EXHIBITIONS: *Institute of American Indian Arts Alumni Show*, Santa Fe, 1987-88; American Indian Archeological Institute, Washington, CT, 1987; *Art of the Seventh Generation*, Roberson Center for the Arts and Sciences, Binghamton, NY, 1986; Solo exhibition, Akwesasne Museum, Hogansburg, 1982.

PROFESSIONAL AFFILIATIONS: Station CKON, Mohawk Community Radio; Founder, *Akwekon Literary Journal*

Jake Sunshine by the River
1988
Felt tip markers
17 x 22"

Americana Suite
1981
Felt tip markers
22 x 17"

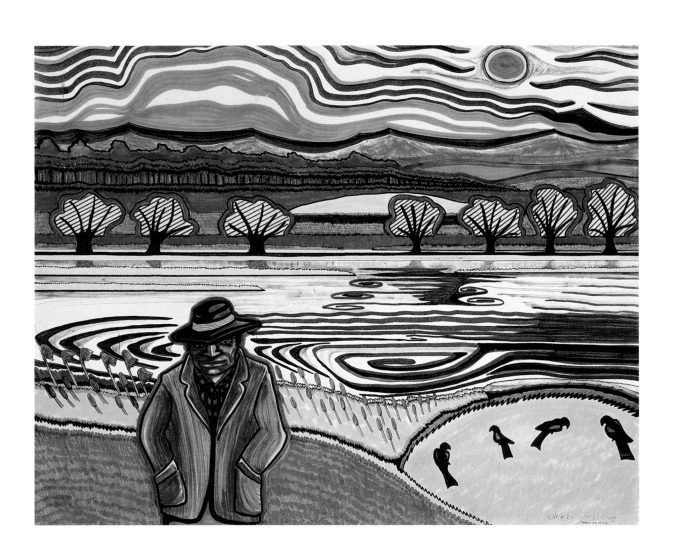

Born: 1945, Silver Creek, New York

Education: University of Siena, Siena, Italy; B.S., State University of New York, Buffalo

Residence: Victor, New York

Selected Recent Exhibitions: *Mid-Career Retrospective* (solo), Museum of the Plains Indian, Browning, MT, 1987; *We the People*, Artists Space, New York, 1987; *We are always turning around on purpose* (traveling), State University of New York College, Old Westbury, 1986; Solo exhibition, Sacred Circle Gallery, Seattle, WA, 1985-86; *Cowboys and Indians: Common Ground*, Boca Raton Museum of Art, Boca Raton, FL, 1985; *Four Native American Painters*, Wooster Art Museum, Wooster, OH, 1985.

Professional Affiliations: Director, Ganondagan State Historic Site, Victor; Board of Regents, Institute of American Indian Arts, Santa Fe, NM

Vanishing American Myth
1988
Color Xerox/mixed media
20 x 25"

All Indians, Don't Live West of the Mississippi
1987
Acrylic/watercolor/china marker
22 ½ x 31"

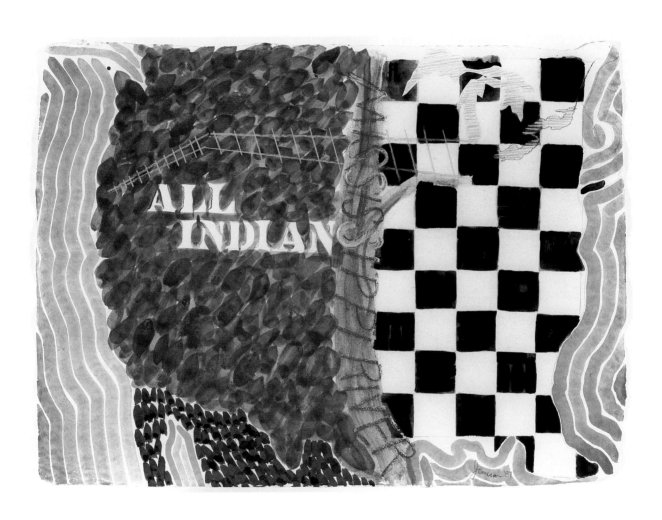

BORN: 1931, California
EDUCATION: Commerce
High School, San Francisco
RESIDENCE: Provincetown,
Massachusetts

SELECTED RECENT EXHIBITIONS: *Past Directors of the Art Association,* Provincetown Art Association, Provincetown, 1987.
PROFESSIONAL AFFILIATIONS: Founder, *Four Winds Press,* Provincetown; Project Director, Federated Eastern Indian League, West Chatham, MA

Staircase, Uxmal, Yucatan
n.d.
Black-and-white photograph
7 ¾ x 7"

Between Two Worlds, Mexico
n.d.
Black-and-white photograph
9 x 6 ¼"

Road to Cocucho, Michoacan
n.d.
Black-and-white photograph
5 ⅜ x 7 ⅞"

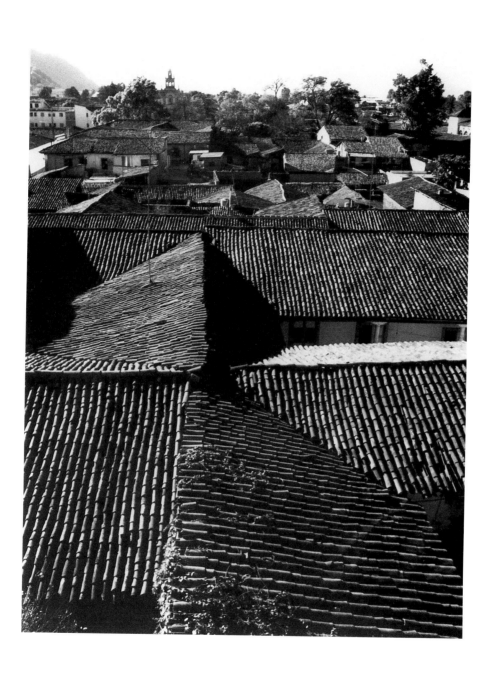

Jean LaMarr

Paiute/Pit River

Born: 1945, Susanville, California
Education: University of California, Berkeley; Kala Institute, Berkeley
Residence: Santa Fe, New Mexico

Selected Recent Exhibitions: *LaMarr* (solo), Bakersfield Community College, Bakersfield, CA, 1990; *Committed to Print*, Museum of Modern Art, New York, 1988-89; *We, The People*, Artists Space, New York, 1987; *Works on Paper*, Museum of the Rockies, Bozeman, MT, 1987; *We are always turning around on purpose* (traveling), State University of New York College, Old Westbury, 1986-87; *Our Contemporary Visions*, Sierra Nevada Museum of Art, Reno, NV, 1986; *Extension of Tradition*, Crocker Art Museum, Sacramento, CA, 1985; *Second Biennial Invitational*, The Heard Museum, Phoenix, 1985.
Professional Affiliations: Faculty, Institute of American Indian Arts, Santa Fe, NM; Jerome Evans Gallery, Zephyr Cove, NV

Pollyanna Princess II
1988
Mixed media
30 x 43 ¼"

Untitled
1990
Mixed media
44 ¼ x 30"

I Heard the Song of My Grandmothers
1990
Screenprint
34 ½ x 46"

Some Kind of Buckaroo
1990
Screenprint
24 x 36"

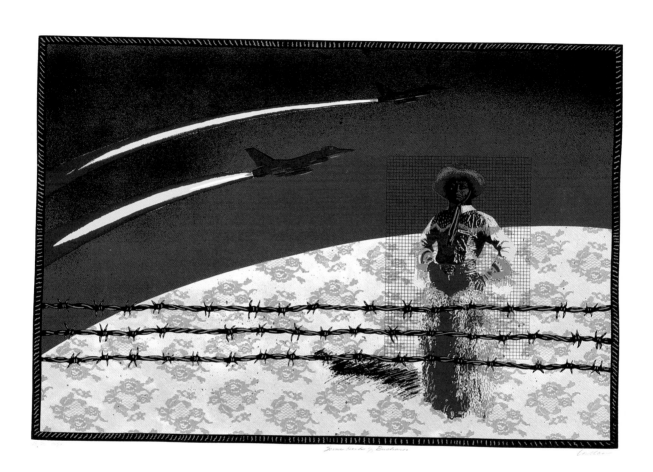

Wintu/Nomtipom

BORN: 1937, San Francisco,
California
EDUCATION: B.A.,
California State University,
Chico; M.A., California
State University,
Sacramento
RESIDENCE: Sacramento,
California

SELECTED RECENT EXHIBITIONS: *Living Arts*, Humboldt
Cultural Center, Eureka, CA, 1990; *Frank LaPena: A
20 Year Retrospective*, Wheelwright Museum, Santa Fe,
NM, 1988-89; *The World is a Gift* (solo), Crocker Art
Museum, Sacramento, CA, 1988; *Recent Generations:
Native American Art 1950-1987*, The Heard Museum,
Phoenix, 1987; *Frank LaPena: Paintings, Monotypes and
Woodcuts*, Sierra Nevada Museum, Reno, NV, 1986;
Progression of Impressions, The Heard Museum, 1986;
Our Contemporary Visions, Sierra Nevada Museum,
1986; *Color, Form and Emergence*, American Indian
Contemporary Arts, 1986; *Extension of Tradition*
(traveling), Crocker Art Museum, 1985.
PROFESSIONAL AFFILIATIONS: Faculty, California State
University, Sacramento; Published poet; Jerome Evans
Gallery, Zephyr Cove, NV

Untitled October 1
1990
Mixed media and collage
12 x 9"

Sacred Spring
1990
Mixed media and collage
12 x 9 ¹⁄₁₆"

New World Flower
1990
Mixed media and collage
12 x 9"

Praying the Four Directions
1990
Mixed media and collage
11 ¾ x 9"

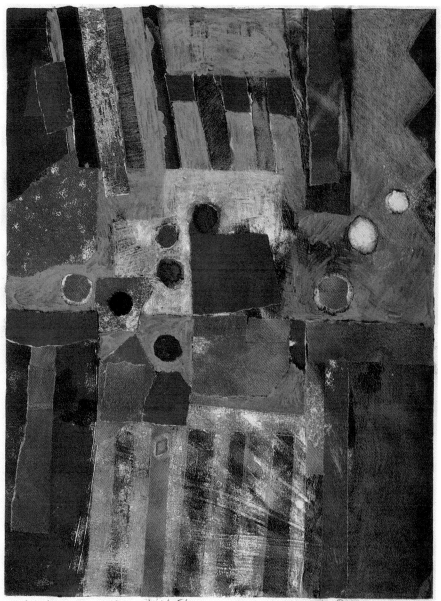

mixed new World flower © W. La Pena 1990

CARM LITTLE TURTLE

Apache/Tarahumara

BORN: 1952
EDUCATION: College of the
Redwoods, Eureka,
California; University of
New Mexico, Albuquerque
RESIDENCE: Cameron,
Arizona

SELECTED RECENT EXHIBITIONS: *Language of the Lens*, The
Heard Museum, Phoenix, 1990; *Ancestors Known and
Unknown*, Coast to Coast, New York, 1990; *Carm Little
Turtle and Ed Singer*, Old Town Gallery, Flagstaff, AZ,
1990; *Personal Preferences: First Generation Native
Photographers*, American Indian Contemporary Arts, San
Francisco, 1989; *As In Her Vision*, American Indian
Contemporary Arts, 1989; *Point of View*, Prescott Fine Arts
Association, Prescott, AZ, 1988; *Women of Sweetgrass,
Cedar and Sage* (traveling), American Indian Community
House Gallery, New York, 1988.
PROFESSIONAL AFFILIATIONS: R.N., Operating Room,
Flagstaff Medical Center; Producer/Photographer,
Shenandoah Films, Arcata, CA

Cowboy Boots Con Pintura
1990
Hand-colored photograph
8 ⅞ x 13"

Bailerina y Tierra
1989
Hand-colored photograph
4 ½ x 6 ⅞"

*She Wished for a Husband,
Two Horses and Many Cows*
1989
Hand-colored photograph
10 ¹⁵⁄₁₆ x 39 ¹⁵⁄₁₆"

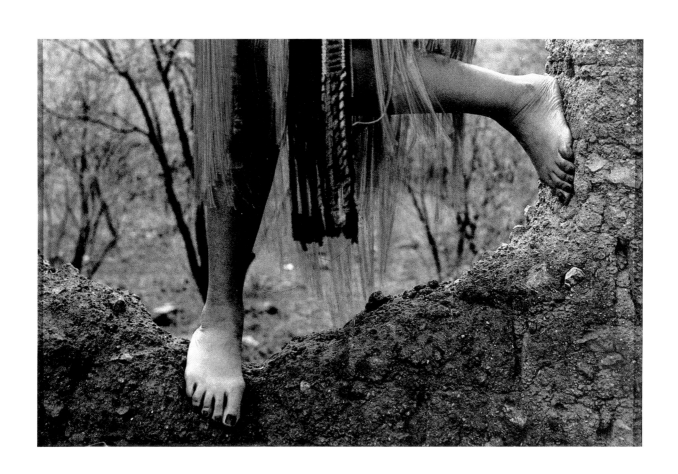

DAN V. LOMAHAFTEWA

Hopi/Choctaw

BORN: 1951, Phoenix,
Arizona
EDUCATION: B.F.A.,
Arizona State University,
Tempe
RESIDENCE: Fort Duchesne,
Utah

SELECTED RECENT EXHIBITIONS: *Direction of the Sun*
(brother and sister exhibit), American Indian
Community House Gallery, New York, 1990; *Spirit
Images* (solo), Amer-Indian Gallery, Steamboat Springs,
CO, 1989-90; *Lomahaftewa* (five-member family
exhibit), Verde Valley Art Association Gallery, Jerome,
AZ, 1989; *Sixty-fifth Spring Salon*, Springville Museum
of Art, Springville, UT, 1989.

Manifest of Song III
1989
Monotype
29 ⅞ x 22 ¼"

Pathfinder #1
n.d.
Monotype
29 ⅞ x 22 ⅛"

Spirit Beings of the Hunt III
1990
Monotype
29 ¾ x 22 ⅛"

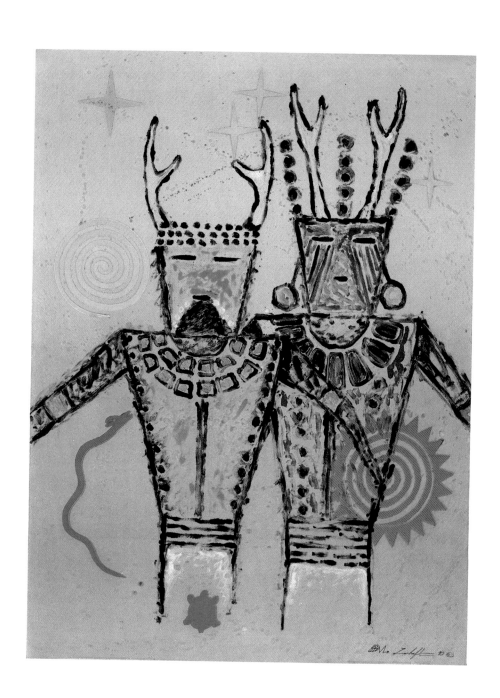

Hopi/Choctaw

BORN: 1947, Phoenix,
Arizona
EDUCATION: B.F.A.,
M.F.A., San Francisco Art
Institute
RESIDENCE: Santa Fe,
New Mexico

SELECTED RECENT EXHIBITIONS: *Contemporary Printmaking in New Mexico: A Native American Perspective,* the Governor's Gallery, Santa Fe, 1990; *Native Proof: Contemporary American Indian Printmakers,* American Indian Contemporary Arts, San Francisco, 1989; *As In Her Vision,* American Indian Contemporary Arts, 1989; *Progressions of Impressions,* The Heard Museum, Phoenix, 1988; *Harmony and Rhythm in Balance,* Indo-Hispano/Nuevo Mexicano, San Antonio, TX, 1987; *Second Biennial Invitational,* The Heard Museum, 1985; Solo exhibition, American Indian Contemporary Arts, 1985; *Women of Sweetgrass, Cedar and Sage* (traveling), American Indian Community House Gallery, New York, 1985. PROFESSIONAL AFFILIATIONS: Faculty, Institute of American Indian Arts, Santa Fe

Circle of Life
1990
Monotype
41 ¼ x 29 ⁵⁄₁₆"

Star Gatherers
1990
Monotype
41 ¼ x 29 ⁵⁄₁₆"

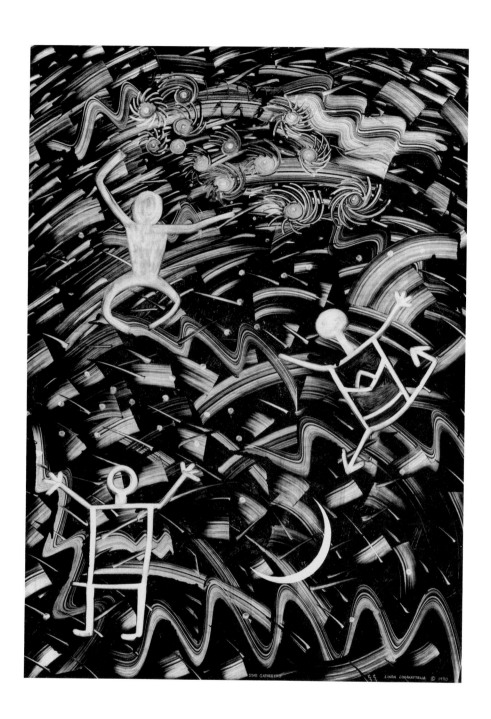

STAR GATHERERS LINDA LOMAHAFTEWA © 1990

GEORGE LONGFISH

Seneca/Tuscarora

BORN: 1942, Ontario, Canada
EDUCATION: B.F.A., M.F.A., School of the Art Institute of Chicago
RESIDENCE: Woodland, California

SELECTED RECENT EXHIBITIONS: *The Decade Show*, The New Museum of Contemporary Art, New York, 1990; *The Power of Process, American Indian Contemporary Arts*, San Francisco, 1990; *George Longfish*, Jennifer Pauls Gallery, Sacramento, CA, 1989; *George Longfish and Roy DeForest*, Natsuolas/Novelozo, Davis, CA, 1988; *George Longfish: New Works*, Heartwood Gallery, Davis, 1987; *The Soaring Spirit: Contemporary Native American Arts*, The Morris Museum, Morristown, NJ, 1987; *The Ethnic Idea: An Artistic Genesis*, Berkeley Art Center, 1987; *Our Contemporary Visions*, Sierra Nevada Museum, Reno, NV, 1986; *Common Ground: New Works by George Longfish*, Bernice Steinbaum Gallery, New York, 1986; *Second Biennial Invitational*, The Heard Museum, Phoenix, 1985.
PROFESSIONAL AFFILIATIONS: Faculty, Native American Studies, University of California, Davis; Director, R.C. Gorman Museum, University of California, Davis; Jennifer Pauls Gallery

Golden Grass Warshirt
1988
Acrylic/beads
49 ⅝ x 49 ⅝"
G.C. Longfish-Courtesy Jennifer Pauls Gallery

Mad Dog Warshirt
1989
Acrylic/reflective tape/medals
15 x 40"
G.C. Longfish-Courtesy Jennifer Pauls Gallery

JACK MALOTTE

Shoshone/Washo

BORN: 1953, Walker River Reservation, Nevada

EDUCATION: California College of Arts and Crafts, Oakland

RESIDENCE: Reno, Nevada

SELECTED RECENT EXHIBITIONS: *Native Proof: Contemporary American Indian Printmakers*, American Indian Contemporary Arts, San Francisco, 1989; *Third Biennial Invitational*, The Heard Museum, Phoenix, 1987; *Traditions in a New Age*, Museum of the Rockies, Bozeman, MT, 1987; *Our Contemporary Visions*, Sierra Nevada Museum, Reno, 1986; *Visage Transcended: Contemporary Native American Masks*, American Indian Contemporary Arts, 1985.

PROFESSIONAL AFFILIATIONS: Freelance Graphic Designer and Illustrator; Jerome Evans Gallery, Zephyr Cove, NV

Untitled
1990
Monoprint
30 x 42 ½"

Untitled
1990
Monoprint
30 x 42 ½"

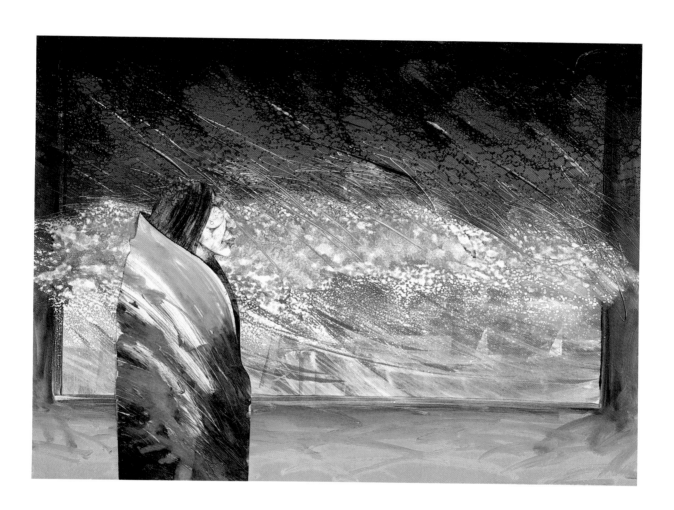

BORN: 1953, Phoenix, Arizona

EDUCATION: B.F.A., Arizona State University, Tempe; M.F.A., San Francisco Art Institute

RESIDENCE: San Francisco, California

SELECTED RECENT EXHIBITIONS: *Fine Art Faculty Exhibition*, Academy of Art, San Francisco, 1989; *Four Sacred Mountains: Color, Form and Abstraction* (traveling), Arizona Arts Commission, 1988-89; American Indian Contemporary Arts, San Francisco, 1987; *Survey*, San Francisco Art Institute, 1987; *Introductions '86*, Gallery Paule Anglim, San Francisco, 1986.

PROFESSIONAL AFFILIATIONS: Faculty, University of California, Berkeley; Gallery Paule Anglim

Yaqui Still Life
1990
Mixed media
44 ½ x 30"

Yoeme Personas
1990
Mixed media
38 x 50"

Flying Sombrero
1990
Mixed media
38 ⅛ x 47"

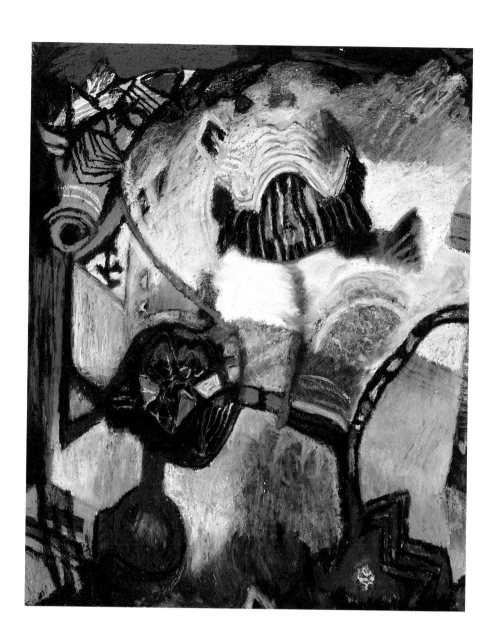

BORN: 1960, Pendleton, Oregon

EDUCATION: A.F.A., Institute of American Indian Arts, Santa Fe, New Mexico; Pacific Northwest College of Art, Portland, Oregon

RESIDENCE: West Richland, Washington

SELECTED RECENT EXHIBITIONS: *Tradition and Spirit,* Maryhill Museum of Art, Maryhill, WA, 1990; *Northwest '87,* Seattle Art Museum, Seattle, WA, 1987; *New Directions Northwest: Contemporary Native American Art,* Portland Art Museum, 1987; *Our Contemporary Visions,* Sierra Nevada Museum, Reno, NV, 1986; *Northwest Art,* American Indian Contemporary Arts, San Francisco, 1985.

PROFESSIONAL AFFILIATIONS: Published poet – American Indian Arts Press, Santa Fe; Greenfield Review Press, Greenfield Center, NY; Wingbow Press, Berkeley; Anthropologist/Archeologist, Battelle Northwest, Richland, WA; Elizabeth Leach Gallery, Portland

The Land Counting Itself: One, Now, Two
1990
Monoprint
10 x 8"

The Land Counting Itself: Three
1990
Monoprint
10 x 8"

The Land Counting Itself: Four
1990
Monoprint
10 x 8"

The Land Counting Itself: Six, Five
1990
Monoprint
10 x 8"

The Land Counting Itself: Seven
1990
Monoprint
10 x 8"

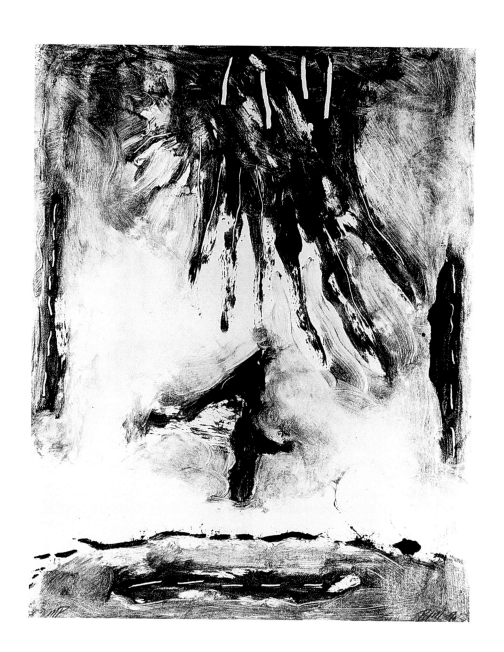

BORN: 1919, Chippewa City, Minnesota
EDUCATION: Art Students League, New York; University of Aix-Marseilles, Aix-en-Provence, France
RESIDENCE: Grand Portage, Minnesota

SELECTED RECENT EXHIBITIONS: *Shared Visons*, The Heard Museum, Phoenix, April, 1991; *Standing in the Northern Lights: George Morrison, A Retrospective*, Minnesota Museum of Art, St. Paul, 1990; Solo exhibition, Tweed Museum, University of Minnesota, Duluth, 1987, 1984; Solo exhibition, University of North Dakota, Grand Forks, 1984; Philbrook Art Center, Tulsa, OK, 1981; Museum of the Southwest, Midland, TX, 1981; Dayton Art Institute, Dayton, OH, 1981; Museo Del Arte, Santiago, Chile, 1980.
PROFESSIONAL AFFILIATIONS: Faculty Emeritus, University of Minnesota, Minneapolis

Spirit Path. New Day. Red Rock Variation: Lake Superior Landscape
1990
Acrylic
22 5/16 x 30 1/16"

Lavender Wind. The Beyond. Red Rock Variation: Lake Superior Landscape
1990
Acrylic
22 1/4 x 30"

Awakening. Time Edge Rising. Red Rock Variation: Lake Superior Landscape
1990
Acrylic
22 5/16 x 30"

Quiet Light. Towards Evening. Red Rock Variation: Lake Superior Landscape
1990
Acrylic
22 3/8 x 30 1/16"

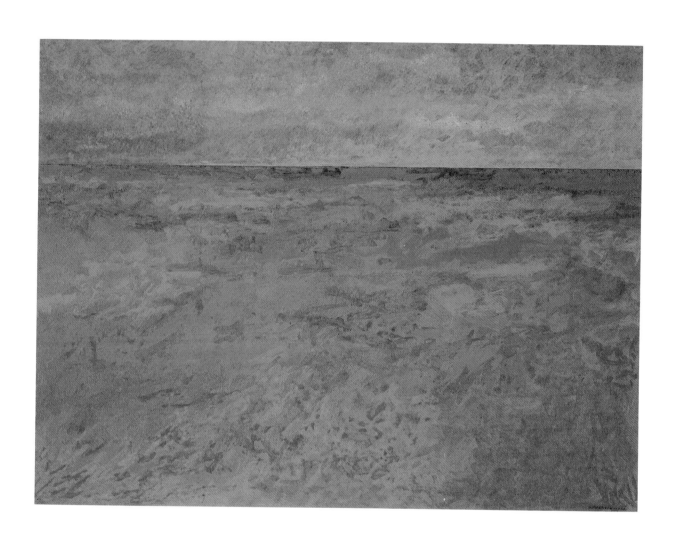

NEIL PARSONS
Blackfeet

BORN: 1938, Browning, Montana

EDUCATION: B.S., M.A., Montana State University, Bozeman

RESIDENCE: Olympia, Washington

SELECTED RECENT EXHIBITIONS: *New Directions Northwest*, Portland Art Museum, Portland, OR, 1987; *New Acquisitions*, The Heard Museum, Phoenix, 1985; Solo exhibition, The Sacred Circle Gallery, Seattle, WA, 1985; *Contemporary Native American Artists*, Pratt-Manhattan Center, New York, 1984; Solo exhibition, The Custer County Art Center, Miles City, MT, 1984; Solo exhibition, The Yellowstone Art Center, Billings, MT, 1983.

PROFESSIONAL AFFILIATIONS: Faculty, Evergreen State College, Olympia

Napumi Series I
1990
Monoprint/collage
28 ½ x 31 ¼

Napumi Series II
1990
Monoprint/collage
31 ¼ x 28 ¾"

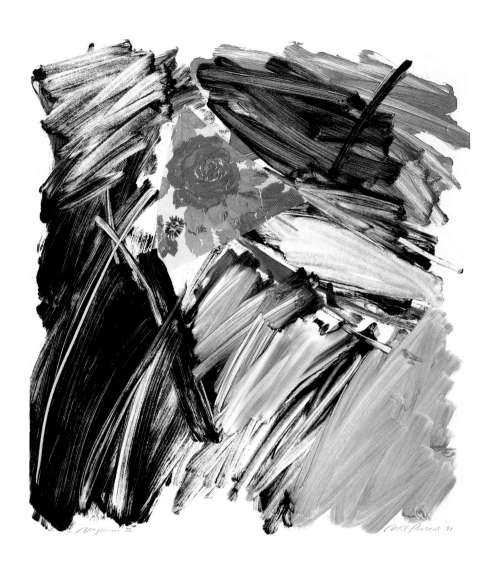

Blackfeet

BORN: 1943, Browning, Montana

EDUCATION: B.F.A, M.F.A., Montana State University, Bozeman

RESIDENCE: Bozeman, Montana

SELECTED RECENT EXHIBITIONS: *New Art of the West*, Eiteljorg Museum of American Indian and Western Art, Indianapolis, 1990; *Environmental Impact Statements*, Missoula Museum of the Arts, Missoula, MT, 1990; *Circle Way: Art of Native Americans* (traveling), Cambridge Multicultural Arts Center, Cambridge, MA, 1989; *Ernie Pepion: A One Man Show*, Museum of the Plains Indian, Browning, 1989; *Call to Rise* (national traveling exhibition for artists with physical challenges), Orlando Museum of Art, Orlando, FL., 1988; *Traditions in a New Age: Contemporary Native American Artists*, Museum of the Rockies, Bozeman, 1987.

Auksokapi
1989
Charcoal/pastel
21 ¼ x 29"

Artist and Assistants
1990
Pastel
22 ¼ x 30 ³⁄₁₆"

Gifts?
n.d.
Pastel
22 ¼ x 30"

Waiting for Me
1990
Charcoal/pastel
22 ³⁄₁₆ x 29 ⅞"

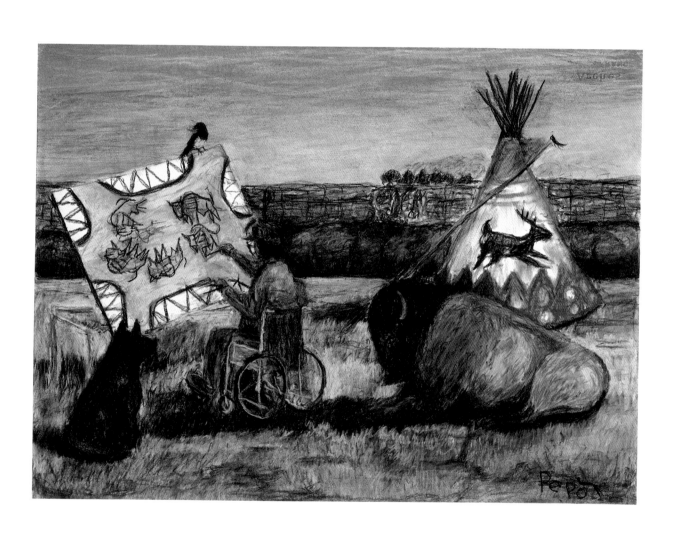

JOLENE RICKARD
Tuscarora

BORN: 1956, Niagara Falls, New York

EDUCATION: London College of Printing; B.F.A., Rochester Institute of Technology, Rochester, New York

RESIDENCE: Sanborn, New York

SELECTED RECENT EXHIBITIONS: *Language of the Lens*, The Heard Museum, Phoenix, 1990; *Compensating Differences*, American Indian Contemporary Arts, San Francisco, 1988; *The Silver Drum: Five Native Photographers* (traveling), Native Indian-Inuit Photographers Association, Hamilton, Ontario and Forest City Gallery, London, Ontario, 1987; *We The People*, Artists Space, New York, 1987; *Photographing Ourselves: Contemporary Native American Photography* (traveling), Southern Plains Indian Museum, OK, and ATLATL, Phoenix, 1985-87; *We are always turning around on purpose* (traveling), State University of New York College, Old Westbury, 1986.

PROFESSIONAL AFFILIATIONS: Art Director, Graphic Designer, Tuscarora, NY

Radar Antlers
1988
Black-and-white and color photographs
18 ¾ x 26"

Self-Portrait - 3 Sisters
1988
Black-and-white photograph/color Xerox
8 ¾ x 20 ⅜"

Separate Paths?
1985
Black-and-white and color photographs
21 ½ x 13"

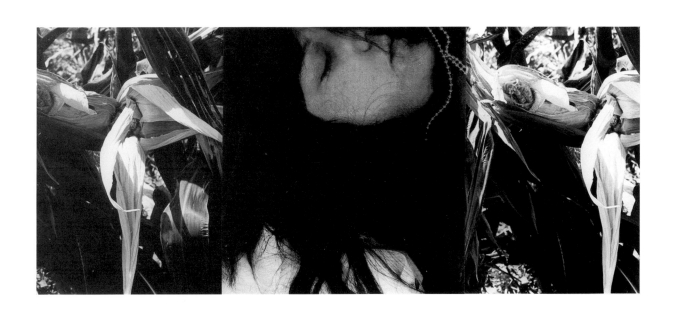

BORN: 1961, Waterloo, Iowa
EDUCATION: B.F.A.,
University of Northern
Iowa, Cedar Falls; M.F.A.,
University of California,
Davis
RESIDENCE: Cedar Falls,
Iowa

SELECTED RECENT EXHIBITIONS: *Fellows Exhibit,* Fine Arts
Work Center, Provincetown, MA, 1990-91; *Artists for
Amnesty,* Natsoulas/Novelozo Gallery, Davis, 1989; *Mayor's
Choice Exhibit* (solo), Cedar Falls City Hall, Cedar Falls,
1988; *Iowa Competitive,* Metropolitan Gallery, Cedar Falls,
1988; *Twenty-fourth Annual Exhibit,* Charles H. McNieder
Museum, Mason City, IA, 1987.
PROFESSIONAL AFFILIATIONS: Visual Fellow, Fine Arts
Work Center, Provincetown

*Diagrams for Landscape and
Other Manifestations*
n.d.
Charcoal
41 ¾ x 29 ½"

Walker
1990
Oil/ acrylic
41 ¾ x 29 ½"

Red Sage/Black Sage
1990
Mixed media
41 ⅜ x 29 ½"

Vessel
1990
Mixed media
41 ⅞ x 29 ½"

Crow/Blackfeet

BORN: 1951, Livermore, California

EDUCATION: B.A., Mills College, Oakland, California; M.A., Montana State University, Bozeman

RESIDENCE: Bozeman, Montana

SELECTED RECENT EXHIBITIONS: *Environmental Impact Statements*, Missoula Museum of the Arts, Missoula, MT, 1990; *Native American Women*, Women's Art Registry, Minnesota Gallery, Minneapolis, 1989; *Native Proof: Contemporary American Indian Printmakers*, American Indian Contemporary Arts, San Francisco, 1989; *Circle Way: Art of Native Americans* (traveling), Cambridge Multicultural Arts Center, Cambridge, MA, 1989; *Four Sacred Mountains: Color, Form and Abstraction* (traveling), Arizona Arts Commission, 1988; *Traditions in a New Age*, Museum of the Rockies, Bozeman, 1987; *Our Contemporary Visions*, Sierra Nevada Museum, Reno, NV, 1986.

PROFESSIONAL AFFILIATIONS: Faculty, Montana State University

Connection
1989
Pastel/mixed media
22 ¼ x 30"

Hummingbird Vision
1990
Pastel/mixed media
30 ⅛ x 22 ¼"

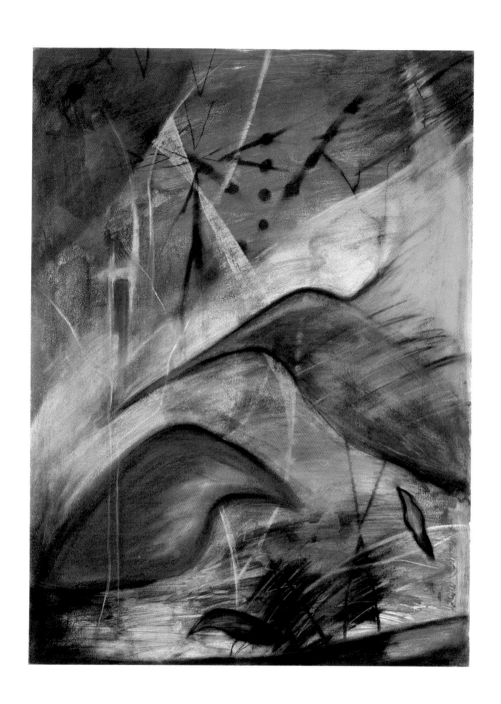

Crow/Blackfeet

BORN: 1953, Livermore,
California
EDUCATION: California
College of Arts and Crafts,
Oakland; B.F.A., Montana
State University, Bozeman
RESIDENCE: Bozeman,
Montana

SELECTED RECENT EXHIBITIONS: *Poetry: An Image in Mind*, Beall Park Art Center, Bozeman, 1990; *Environmental Impact Statements*, Missoula Museum of the Arts, Missoula, MT, 1990; *We Are Part of the Earth*, Centro Cultural de la Raza, Balboa Park, San Diego, 1990; *Hammer, Nail and Brush*, Centro Cultural de la Raza, 1990; *Native Proof: Contemporary American Indian Printmakers*, American Indian Contemporary Arts, San Francisco, 1989; *Four Sacred Mountains: Color, Form and Abstraction* (traveling), Arizona Arts Commission, 1989; *Twenty-nine Montana Artists*, Museum of Modern Art, San Francisco, 1989; *Montana Dream Reflections: Absoolaka* (solo), American Indian Contemporary Arts, 1988; *Traditions in a New Age*, The Museum of the Rockies, Bozeman, 1987; *Our Contemporary Visions*, Sierra Nevada Museum, Reno, NV, 1986.
PROFESSIONAL AFFILIATIONS: ATLATL Regional Board; President, Montana Indian Contemporary Arts Board

Awé Series
1990
Monotype
40 ⅛ x 28 ½"

Awé Series
1990
Monotype
40 ⅛ x 28 ½"

Awé Series
1990
Monotype
40 ⅛ x 28 ½"

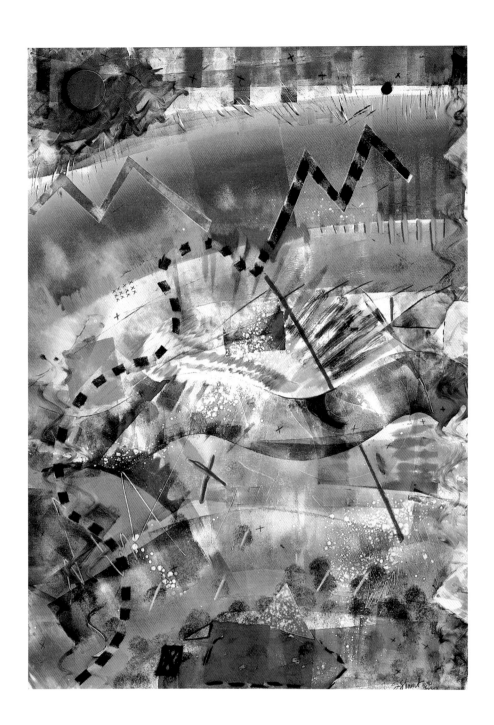

JEFFREY M. THOMAS
Onondaga/Cayuga

BORN: 1956, Buffalo,
New York
EDUCATION: State
University of New York,
Buffalo
RESIDENCE: Winnipeg,
Manitoba

SELECTED RECENT EXHIBITIONS: *Beyond Blue Mountains:
Works of Traditional and Contemporary Native American
Artists*, Olympia, WA, 1986; *The Traditional Dancer* (solo),
Thunder Bay National Exhibition Center, Thunder Bay,
Ontario, 1985; *Visions: Exhibition of Native Photographers*,
The Photographers' Union, Hamilton, Ontario, 1985; *The
Photograph and the American Indian*, Princeton University,
Princeton, NJ, 1985.

*Corn Husk Series, Six
Nations Reserve*
1982
Black-and-white photograph
9 9/16 x 13"

*Corn Husk Series, Six
Nations Reserve*
1982
Black-and-white photograph
9 x 13"

*4 Dancers, Niagra Falls,
New York*
1985
Black-and-white photograph
7 x 10 ¾"

*Main Street, Winnipeg,
Manitoba, Canada*
1990
Black-and-white photograph
8 x 13"

72

73

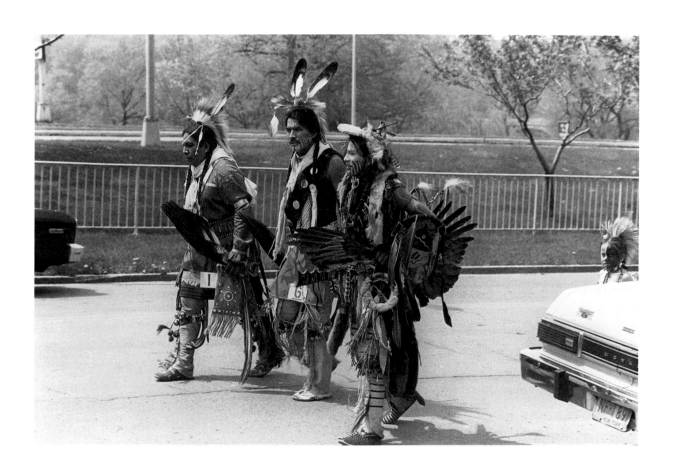

KAY WALKINGSTICK

Cherokee/Winnebago

IS THAT YOU? II

BORN: 1935, Syracuse, New York

EDUCATION: B.F.A., Beaver College, Glenside, Pennsylvania; M.F.A., Pratt Institute, Brooklyn, New York

RESIDENCE: Long Island City, New York

SELECTED RECENT EXHIBITIONS: *Lines of Vision: Drawings by Contemporary Women* (traveling), Hillwood Gallery, C.W. Post College, Long Island University, Brookville, NY, 1989; Solo exhibition, M-13 Gallery, New York, 1989, 1987; Solo exhibition, Wenger Gallery, Los Angeles, 1988; *Fortieth Annual Purchase Exhibition*, American Academy and Institute of Arts and Letters, New York, 1988; *We the People,* Artists Space, New York, 1987; *The Soaring Spirit: Contemporary Native American Arts*, Morris Museum, Morristown, NJ, 1987; *Our Contemporary Visions,* Sierra Nevada Museum, Reno, NV, 1986; Two person exhibition, R.C. Gorman Museum, University of California, Davis, 1985; *Second Biennial Invitational*, The Heard Museum, Phoenix, 1985.

PROFESSIONAL AFFILIATIONS: Faculty, State University of New York, Stony Brook; M-13 Gallery

Autumn Compliments
Sketch I
1988
Oil stick
18 x 36"

Is That You? II
1990
Charcoal
29 $^{13}/_{16}$ x 59 $^{15}/_{16}$"

74
75

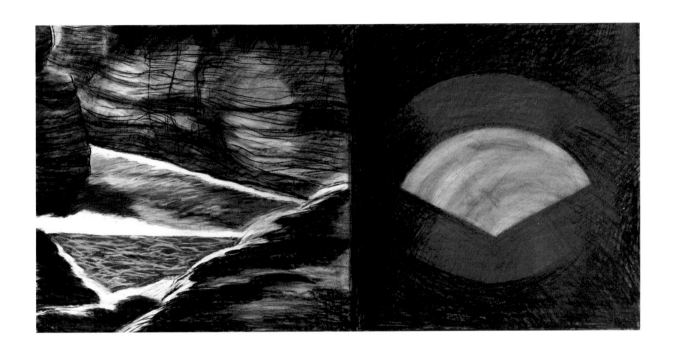

BORN: 1947, Henryetta, Oklahoma

EDUCATION: B.A., Tyler School of Art, Temple University, Philadelphia; M.F.A., American University, Washington, D.C.

RESIDENCE: Oneonta, New York

SELECTED RECENT EXHIBITIONS: *Common Threads: Hybrids of Substance II*, Schweinfurth Art Museum, Auburn, NY, 1990; *Kiva and Canyon: Drawings, Paintings and Paperworks* (solo), Upper Catskill Council on the Arts, Oneonta, 1989; *Selections from 'Art on the Wind'* (traveling), Upper Catskill Council on the Arts, 1989; *Paper/Fiber '89*, Holter Museum of Art, Helena, MT, 1989; *Ritual Spaces in the Body of the Land: Paperworks and Works on Paper* (solo), Holter Museum of Art; Greensboro College, Greensboro, NC; State University of New York, Oswego, 1988-89.

PROFESSIONAL AFFILIATIONS: Faculty, Hartwick College, Oneonta

Excavated Memories: Wounded Canyon, I
1984
Dyed/pigmented linen and cotton
30 ½ x 22 ½"

Excavations: Wounded Canyon Spirit Speaking
1984
Dyed/pigmented linen and cotton
30 ½ x 25"

SELECTED BIBLIOGRAPHY

1980 Katz, Jane B. (ed.) *This Song Remembers: Self Portraits of Native Americans in the Arts.* Boston: Houghton Mifflin.

1980 Amerson, L. Price and Gordon, Allan M. *Confluences of Tradition and Change.* Davis, CA: University of California (catalogue essays).

1980 Highwater, Jamake *The Sweet Grass Lives On: Fifty Contemporary North American Indian Artists.* New York: Lippencott and Crowell.

1981 Wade, Edwin L. and Strickland, Rennard *Magic Images: Contemporary Native American Art.* Norman, OK: University of Oklahoma Press.

1982 Longfish, George and Randall, Joan "New Ways of Old Visions: The Evolution of Contemporary Native American Art." Third Conference of Native American Art Historians (paper).

1983 Longfish, George "Contradictions in Indian Territory." *Contemporary Native American Art.* Stillwater, OK: Oklahoma State University (catalogue essay).

1983 Younger, Erin "Contemporary Native American Art-Historical Background." *Contemporary Native American Art.* (catalogue essay).

1984 Broder, Patricia Janis *The American West: The Modern Vision.* Boston: Little, Brown and Co.

1985 Lippard, Lucy R. "Double Vision," *Women of Sweetgrass, Cedar and Sage: Contemporary Art by Native American Women.* New York: American Indian Community House Gallery (catalogue essay).

1985 Brown, Christopher "Contemporary Indian Art: A Critic's View." *The Extension of Tradition.* Sacramento, CA: Crocker Art Museum (catalogue essay).

1986 Durham, Jimmie "Ni 'Go Tlunh A Doh Ka," *We are always turning around on purpose.* Old Westbury, NY: State University of New York College (catalogue essay).

1986 Hill, Richard *Art of the Seventh Generation.* Binghamton, New York: Roberson Center for the Arts and Sciences (catalogue essay).

1987 Fisher, Jean and Durham, Jimmie *We the People.* New York: Art Space (exhibit brochure essays).

1987 Randall, Joan and Longfish, George "Runners Between the Tribes," *New Directions Northwest: Contemporary Native American Art.* Portland, OR and Olympia, WA: Portland Art Museum and Evergreen State College (catalogue essay).

1987 Tremblay, Gail "Carriers of Culture: Contemporary Native American Art in the Pacific Northwest," *New Directions Northwest: Contemporary Native American Art* (catalogue essay).

1988 Hartman, Diane *The Soaring Spirit.* Morristown, NJ: The Morris Museum.

1990 Lippard, Lucy R. *Mixed Blessings: New Art in a Multicultural America,* New York: Pantheon Books